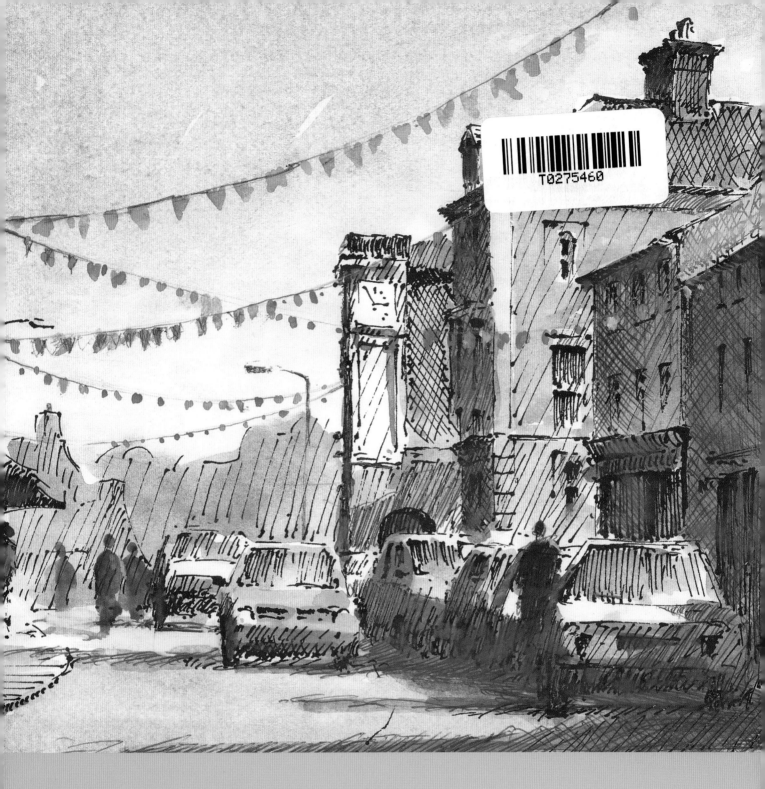

Sketching for the
Absolute Beginner

Dedication

I have always been slightly dyslexic and at the age of eight it was decided that I was 'slow' or 'remedial' as it was rather callously called then. The solution was Mr Gavin's special class, one morning a week, which I think was meant to bring me and a few others 'up to speed' with reading and writing.

At the first class this balding, gentle man took up a pencil and started drawing a wild west horse rearing up in front of a cowboy, narrating a story as he drew.

I remember that it just knocked me sideways: the fact that this person could just conjure such images and emotions with a mere pencil. Each week we had a different sketch accompanied by a different story. I was hooked.

I never got to thank Mr Gavin, and I presume he has passed away by now, but I shall never forget kind, gentle Mr Gavin. I still can't spell though!

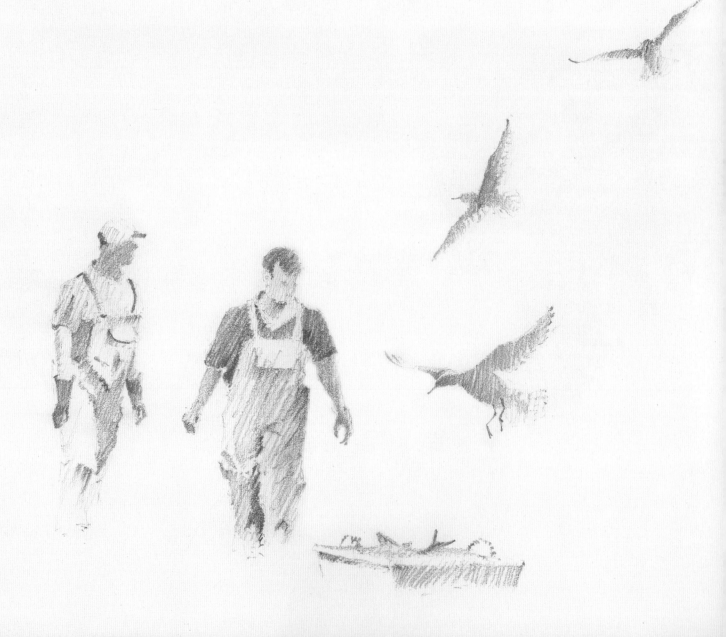

Sketching for the
Absolute Beginner

PETER CRONIN

Search Press

First published in 2022

Search Press Limited, Wellwood, North Farm Road,
Tunbridge Wells, Kent TN2 3DR

Reprinted 2022, 2023, 2024

Illustrations and text copyright © Peter Cronin 2022

Photographs by Mark Davison at Search Press Studios,
and the author

Photographs and design copyright © Search Press Ltd 2022

ISBN: 978-1-78221-874-6
ebook ISBN: 978-1-78126-843-8

Publishers' note
The Publishers and author can accept no responsibility for
any consequences arising from the information, advice or
instructions given in this publication.

Readers are permitted to reproduce any of the artwork in
this book for their personal use, or for the purpose of selling
for charity, free of charge and without the prior permission
of the Publishers. Any use of the artwork for commercial
purposes is not permitted without the prior permission of
the Publishers.

Suppliers
If you have difficulty in obtaining any of the materials and
equipment mentioned in this book, then please visit the
Search Press website for details of suppliers:
www.searchpress.com

You are invited to visit the author's website at:
www.petercronin.org

Printed in China

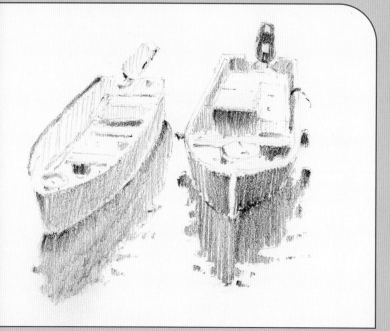

Acknowledgements

Thanks must go to my wife, for her patience
in tolerating my pontifications with a pencil,
Mr Gavin for sparking the light, Adrian Hill for
his inspirational books, and Edd and the gang
at Search Press for putting it all together.

Left
Two Boats
Sitting on a sunlit jetty with calm water and a pencil.

Page 1
Cardigan Town
*Before I gained the knowledge that is shared between
these pages, such a scene as this would have been beyond
my capability, and there is nothing worse than having an
emotional reaction that you cannot respond to, due to lack of
technical prowess.*

Page 2
Sorting the Catch
*Once we learn to use the humble pencil well, nothing is beyond
our 'catch'.*

Page 3
Field View
*It was cold, very cold, when I made this sketch. I thought charcoal
would speed my sketching up – and it did!*

Opposite
Italian Corner
*I liked the light hitting the side of the building, and relative chaos
below. This sketch was worked in sepia ink.*

FSC
MIX
Paper | Supporting
responsible forestry
www.fsc.org FSC® C012521

Contents

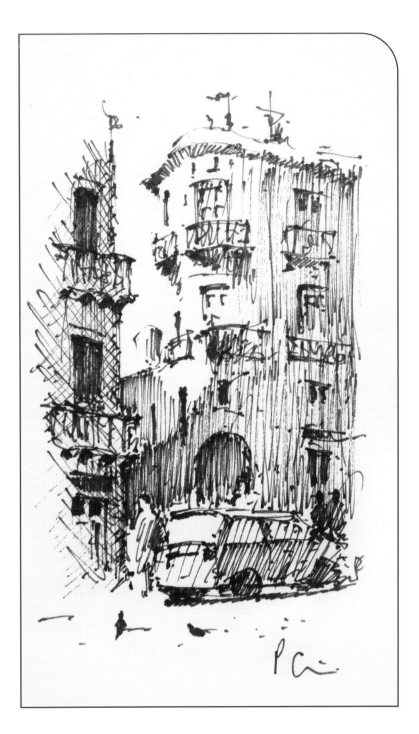

Introduction

The ability to manipulate a pencil to make the right marks
to illustrate thoughts, objects and ideas is a wonderful thing
indeed, but why sketch? In today's world of technological
wizardry, why bother?

I remember making a conscious decision to start to paint,
but cannot remember making the same decision with regard
to drawing or sketching. Every child scribbles and daubs paint,
so why did this child stop daubing but continue to scribble?
I don't think there's a simple answer to that, but we explore the
craft in this book.

For this artist, the answer to the question 'why bother?'
is manifold, but mainly it's because of the sheer buzz and
absorption of the process. Note that I say the process – not the
finished sketch. Seeing the resulting sketch is very satisfying,
but not half as satisfying as producing it. This is because at its
best, sketching induces a process called 'flow' – an idea that
stems from the research of Mihaly Csikszentmihalyi (but more
directly, my wife told me about it, so it must be true) – though
an absolute novice might only achieve a 'drippy run' first time.
My hope is that this book gives you the tools and confidence to
get into that state of flow with your sketching.

I am a full-time professional artist, and if I had to name one
thing that has improved my painting, then it would be drawing.
In traditional art, if the shapes of the objects you're painting
don't convince, then the painting fails. Sketching gives you
a fuller understanding of virtually everything involved in
picture-making and painting.

There are a few simple rules to sketching and the study of
these, along with diligent practice, will soon produce results.
This book aims to combine information with inspiration and
thus teach you the sublime art of sketching.

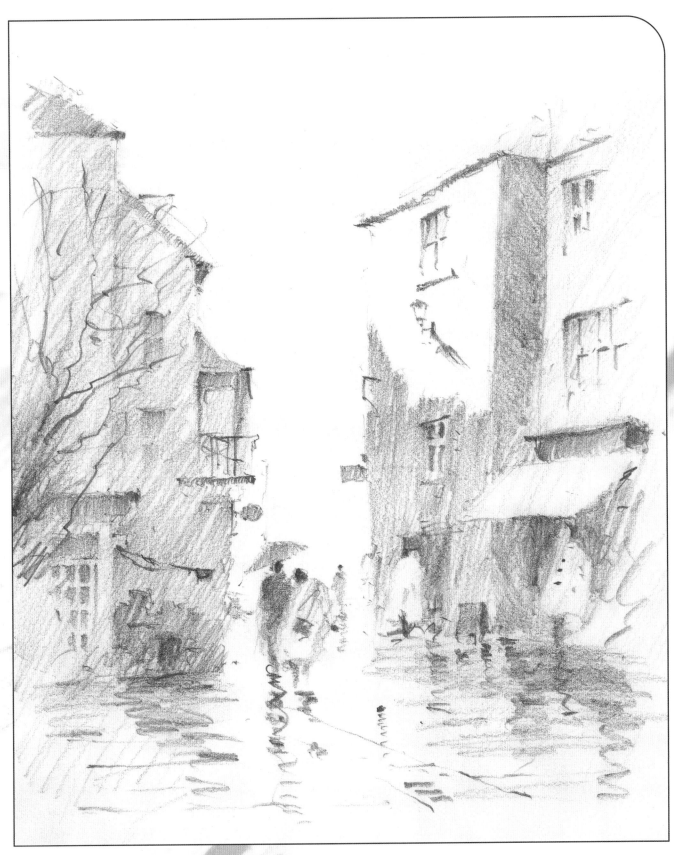

Sun Showers

Don't you just love rainy streets? This was sketched from under an awning, just as the shops were closing and the sun poked through the cloud.

Materials

In today's technologically-driven world of hyperbole, how on earth do the pencil and sketchbook survive? One of the many joys of sketching is that you do not need a lot of equipment. Among the many things in its favour are simplicity, practicality, and versatility.

It is false economy to skimp on the basic materials of pencil and paper, as this will affect both your efforts and outcomes. Inferior tools undermine the pleasure of sketching, the actual result, and the permanence of your efforts.

Pencil

A pencil to an artist is like a scalpel to a surgeon: an essential tool. Sketching with an inadequate pencil is akin to carrying out an operation with a blunt penknife – don't do it. (Especially the surgery!)

Pencils are graded from H, through HB, to B. These grades denote hardness. The higher the H number, the harder the pencil. A 5H, for example, is harder than a 4H. The B stands for blackness; the higher the number, the softer the pencil and blacker the mark. HB is a mid-point between the two.

The H pencil is for the draughtsperson and has no place in the hand of the artist, due to its inability to create a full dark mark. We require pencils in the B range. These are softer and thus able to produce the range of marks we require. As a minimum we require a 2B, but some artists prefer as soft as a 5B.

The benefit of a softer pencil lies in its sensitivity and the ease with which darks are produced. Its downsides are that the marks are easily smudged and the point will perish after only a few strokes. A fixative spray will help with the smudging but is an extra piece of equipment.

An added complication is that one manufacturer's 2B may be as soft as another's 4B, but as you gain more experience in the craft of sketching you will find what best suits the job at hand and your temperament.

The evil of the eraser

When using charcoal for life drawing or portraiture, the putty eraser is a necessary and useful tool, but to the pencil sketcher the use of the eraser is simply a bad habit born of a erroneous approach. It usually produces both an unkempt, messy, smudgy sketch and an irate, dissatisfied student.

Very, very rarely do I produce a sketch without making errors along the way; but I never rub these erroneous lines out. Indeed, they help me to place the correct line more easily. There is a lovely saying that states, 'you have to make a wrong line to make a right line'.

Rather than using an eraser, we should stick by the axiom 'light lines first'. We shall discuss the reasons for this later in the book.

Types of pencil

Different types of pencil will produce marks that vary in their variety and character. I look for a pencil that is not so hard that it has little in the way of tonal range, but not so soft that it will crumble and become smudged when pages of the sketchbook rub together. Smudging can be prevented by spraying with fixative or non-perfumed hair lacquer.

Hard H-grade pencils

Only light tones are available with an H pencil, regardless of how hard it is pressed against the paper. The mark also stays very similar, as the point does not wear down much during the sketch.

The sketch on the right, produced using a hard H pencil, has a very limited range of tone.

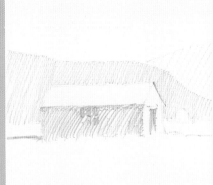

Soft B-grade pencils

Soft pencils produce marks that range from light grey through to quite strong darks, depending on how much pressure is placed on the pencil. The pencil line also varies, becoming thicker as the point wears down during the sketch. This is useful when we wish to hatch larger areas and to get a sharper line: we simply change the angle of the pencil.

The sketch on the right , produced using a softer 3B pencil, shows a wider tonal range than the one made with a hard pencil.

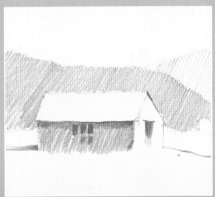

Other types of pencil

It is well worth experimenting with what you use – after all, you can sketch with anything that leaves a mark. Below are shown the marks a selection of other pencils will make.

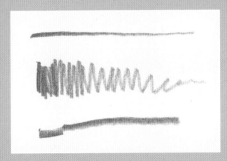
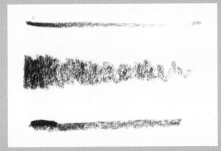
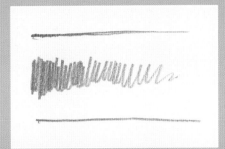

Carpenter's pencil

Carpenter's pencils are wider than they are tall, so that they don't roll about. They have a broad lead, which means you can make broad or narrow marks by adjusting the angle at which you use it.

Charcoal pencil

With charcoal in place of the graphite lead, this very soft pencil can produce very dark marks. It's a cleaner option than sticks of charcoal; but you do need to fix it in place once you finish to avoid smudging.

Clutch propelling pencil

2B grade leads are available for these pencils, allowing for good darks (in comparison with HB). The mark tends to be consistent, as there is no increase in line width as the graphite wears down. I like to use these to produce a more refined 'drawing' as opposed to the looser sketch.

Pen

I sometimes use a pen, both for sketching and producing pen and wash studies. The ink must be waterproof as I don't want it to run when the washes are applied over the penwork. I also prefer a thicker nib as I can get a variety of marks from full bold lines to sketchy loose lines.

We look at working with pen in more detail on pages 66–75, so for now some general notes will suffice. For general sketching, a fineliner pen with waterproof ink and a nib size between 0.5 and 0.8 is ideal.

I am not that particular with regard to manufacturers, and have on occasion used a black ballpoint pen.

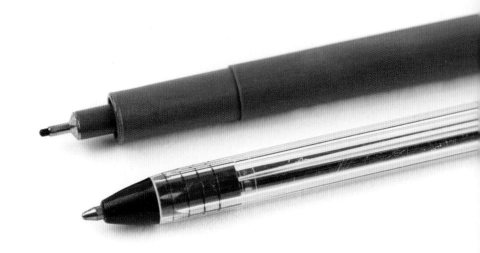

The first time that I ever sketched with a pen was in Greece. At the time, I felt that a pencil just did not achieve the effect of sunlight as well as a pen, which so easily achieves the deeper dark tones required for such an effect. (I have since discovered that it was my timidity with a pencil that was at fault – I was shy and so was my pencil.)

We were in the middle of nowhere and in order to obtain a pen I had to convince the lady who I was with at the time – a very keen writer – that a 4B soft pencil was, in fact, a top class writing implement. I don't know why that relationship didn't last!

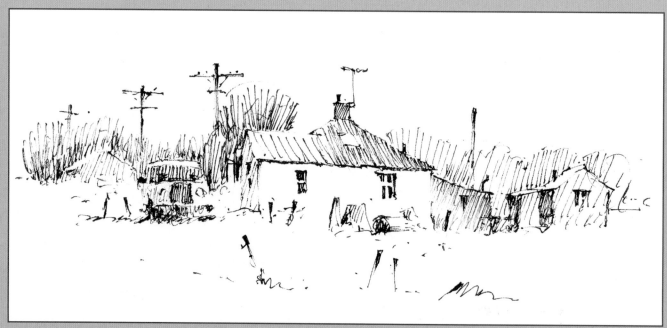

A Little House, New Zealand

This sketch was produced with a ballpoint pen and is very loose and immediate. It is quite hard to vary the marks using such a pen, as it does not respond well to being laid over on its side (see page 67). I had to use it lightly and quickly for the lighter marks with a slower, more upright technique for the darker elements.

Charcoal

Charcoal is willow (or vine) wood that has been burnt in an airless oven. It comes in a variety of shapes and sizes and can be used whole or broken to suitable lengths, depending on the size of the sketch and your personal preference.

Some artists will use an A3 (30 x 42cm/11¾ x 16½in) size book for charcoal sketches, as it can be a loose and liberating medium. I tend to use my standard A4 (21 x 30cm/8¼ x 11¾in) books, as they are easier to carry and use in the wind.

Using watercolour paper with a textured Not surface gives lovely results with charcoal. This is explained in more detail in the section on charcoal on pages 80–83. In addition to the sticks themselves, using charcoal benefits from a few extra materials, too:

Putty eraser While an eraser is a 'terrible tool of the timid' in pencil sketching, it takes on a whole new role when used with charcoal, allowing you to create light areas by rubbing away the easily-removed charcoal marks.

Fixative Charcoal sketches carried out on the move in a sketchbook will inevitably smudge, so some form of fixative to stop them rubbing together and turning into a misty mess is helpful.

Wet wipes Charcoal can be messy and I often emerge from a simple sketch looking like a coal miner after a heavy shift. Wet wipes are both affordable and portable.

Blending stump Also called tortillons, these paper rolls are used to soften charcoal into the surface. This is shown in more detail on page 81.

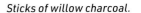

Sticks of willow charcoal.

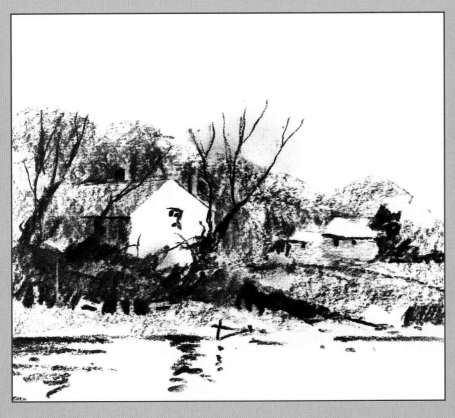

Flooded Field, Ewenny

All the information for a painting is here in this sketch – and due to the ability of charcoal to lay broad areas quickly, it took no more than five minutes to make. Charcoal makes a virtue of brevity.

A version of this sketch is shown in the exercise on pages 82–83, if you'd like to give it a go yourself.

Watercolour paints and brushes

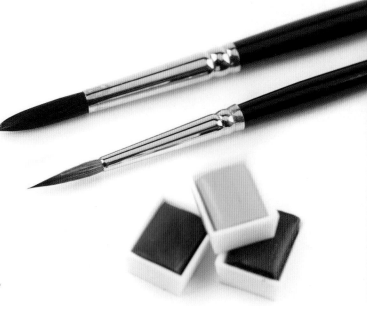

Sketching is not restricted to monochrome, and pen and wash – that is, using watercolour to paint over a pen sketch – is an enjoyable way to bring colour into your work.

Using watercolours to complement your pens and pencils is explained in more detail on pages 70–77. It is important, however, to remember that we are sketching, not producing complex paintings. As with your other tools, the same minimal philosophy applies.

Watercolour paint

Paints are available as either pans of hard pigment or soft, in tubes. I find a small box of paints in half-pans (that is, half the standard pan size) preferable to tubes: pans are more easily accessible, with less set-up and organisation necessary. They wet down and come alive more quickly than tube paint that has been squeezed out and has dried on the palette.

Watercolours are available in different qualities, too. I always use artists' quality paints for my watercolour paintings as they are more finely ground and richer in pigment; but cheaper, less richly-pigmented students' quality paints are fine for use in your sketchbook, where quality of wash is not so critical.

Paintbrushes

Brushes come in many different sizes, with flat, round and all sorts of fan type models. We do not require a wide range. We are sketching and we do not want to be fiddling around with five or six different paintbrushes.

Ordinary round brushes will be fine for our needs. One round size 8 brush with a fine point is all we need to lay the washes and make finer marks as required. The other option is to have a larger 10 or 12 brush for the bigger areas and a small pointed brush or rigger for any smaller marks. A rigger is a fine brush with long pointed hair and is useful for fine lines. I keep an old one in my sketch bag, but use it only rarely as I tend to make my finer marks with the pen or pencil.

What colours?

Rest assured that you don't need many paints for sketching with watercolour. My portable palette contains:

- Cadmium red
- Cadmium yellow
- Cadmium orange
- French ultramarine
- Cerulean blue
- Raw sienna
- Burnt sienna
- Hooker's green
- Chinese white

My portable palette is compact and folds away quickly. It contains my paints, a few clean spaces on which to mix colours and a little water pot – that's all you need to sketch.

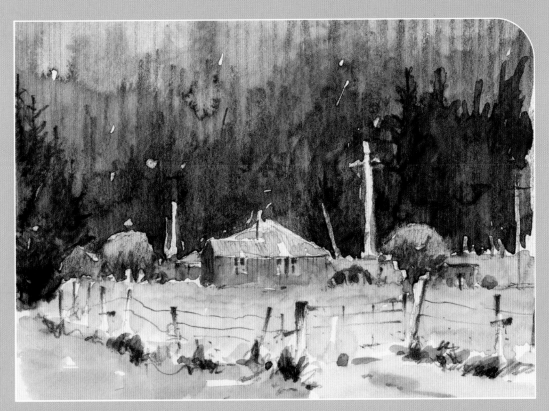

Farm, New Zealand

A rapid pencil and watercolour sketch, made using a few simple shapes. I loved the colours on the tin building and the way they contrasted with the dark backdrop: capturing this was key to the sketch, and using paint allowed me to build up the contrast in tones very swiftly. Some drastic simplification has been carried out on the conifer-lined hill behind.

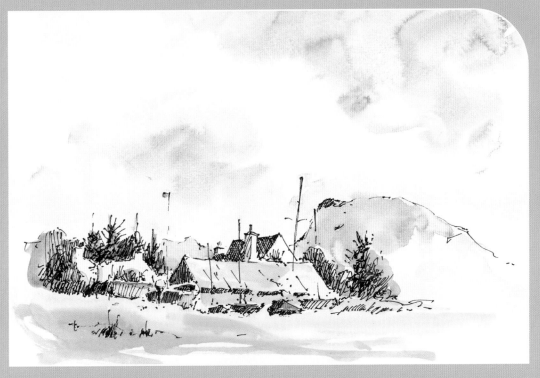

Plockton

Pen and wash. There was a folk group practising in the garden of the pub and I sketched in the sun with Scottish music floating over the air. Notice how the pen has been used to suggest the darker tones and accents like masts and similar details.

Sketchbook

A good sketchbook will take every weight of mark well, from the lightest of strokes to the strongest darkest accent.

Sketchbooks come in many shapes and sizes, from small pocket books all the way up to A1 (59.5 x 84cm/23½ x 33in), though these large monsters are not practical as an on-site tool. A4 (21 x 30cm/8¼ x 11¾in) is a practical size, with A5 (15 x 21cm/6 x 8¼in) being well-suited to the car glovebox, handbag, or pocket.

A good example sketchbook that has everything I look for. The hardback cover works as a support while sketching. As you can see, the fact that it lies flat allows me to work right across the spine where necessary, opening up the possibility of larger sketches.

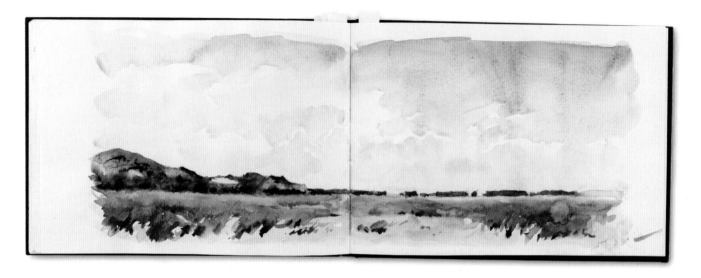

What to look for in a sketchbook

After many years and more than a few sketchbooks, this is what my current favourite book would look like.

Paper weight A good weight, such as 240gsm (90lb) will take a watercolour wash quite easily without cockling or buckling.

Moderate texture The paper texture, sometimes called 'tooth', should be enough to take the graphite from the pencil, but not so rough as to break the pencil line up when shading. Sketchbook paper is usually hot-pressed (HP), which means it is smooth; or Not – short for Not hot-pressed, and sometimes called cold-pressed, or CP – which has a moderate texture.

Hard cover A stiff hardback front and rear cover will support and protect the book in use. A well-glued spine helps to avoid pages becoming detached during use, too.

Lies flat Sketching across both pages of a pad that will lie flat when open is a good option to have, as shown above.

What to avoid in a sketchbook

Similarly, experience has taught me that the following points make a sketchbook impractical, frustrating or downright unpleasant to use.

Thin paper Thin paper crimples and deteriorates quickly, is usually very smooth and buckles horribly when taking a wash of watercolour paint.

Texture Paper that is too smooth – or equally, too rough – makes certain techniques difficult.

Big round wire spines These are bulky and seem to get caught in everything.

Weak spine A spine that breaks down with use and starts to lose pages is frustrating.

Floppy cover A thin cover will not act as a stiff, rigid support for the book's pages.

Fancy covers It's personal, but I am not a fan of fancy covers. They cost a lot more than a normal cover and you could spend the money on another sketchbook. Also after some hard use in the field they start to look very unfancy.

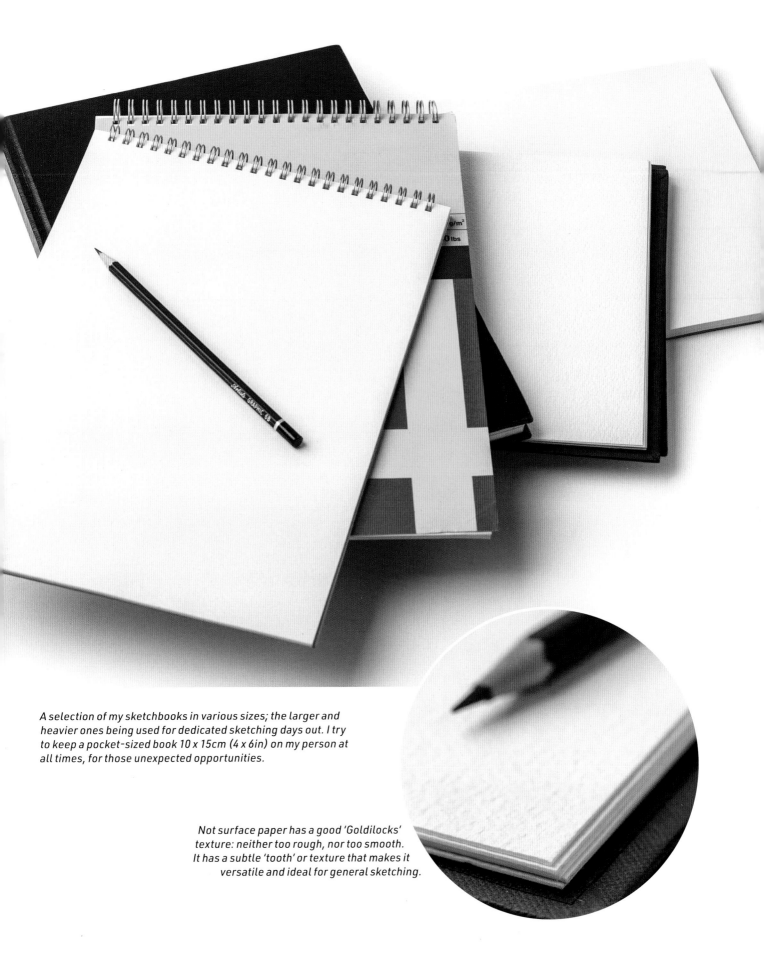

A selection of my sketchbooks in various sizes; the larger and heavier ones being used for dedicated sketching days out. I try to keep a pocket-sized book 10 x 15cm (4 x 6in) on my person at all times, for those unexpected opportunities.

Not surface paper has a good 'Goldilocks' texture: neither too rough, nor too smooth. It has a subtle 'tooth' or texture that makes it versatile and ideal for general sketching.

Other tools and materials

Seat Some kind of lightweight seat is useful when sketching outdoors, although with practice it's quite possible to sketch standing up. I have a number of options depending on how far I intend to walk. I find a stool is fine unless the ground is very steeply sloped or uneven, in which case I use a waterproof foam pad type seat instead. I also have an intermediate seat/pad model that offers slightly more comfort.

Bag I have both a small 'manbag' for general use, and a larger rucksack for more intense voyages. I also have a very small sketchbook that fits in the pocket (for when my wife Teena doesn't know that we are going out sketching).

Pencil sharpener I carry at least two or three pre-sharpened pencils, ready for sketching, but I do possess a small pencil sharpener in my sketch bag. I have not seen it for a few months, but I do know it's lurking in some deep corner somewhere.

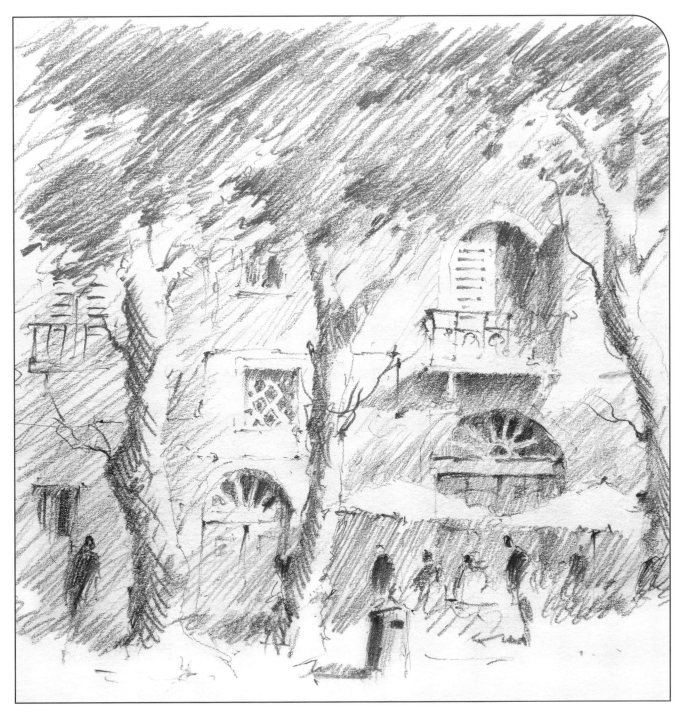

A note on tablets

I am becoming more and more aware of the ever-nearing presence of the drawing app. I believe that one day they may even get close in feel and response to a physical sketchbook. Like many computerized devices, tablets have a role to play but I personally find them very limiting. The fact that it's you and a thousand software technicians just does not appeal to me.

The sketchbook and pencil is simple, versatile and never needs recharging. It will tolerate rain or bright light on its surface – and, unlike a tablet, can be dropped a considerable distance.

Lucca

A very rapid sketch made while waiting for a bus that was – perhaps inevitably, perhaps fortunately – running late.

The eye, the hand and the heart

Sketching with emotion and expression

Sketching is a wonderful way for the novice to explore creativity. The consequences of errors and mistakes are light; and with the simplest equipment of probably any art form, there need be no huge financial outlay. It does not have the 'set up', 'packing up' or 'space to work' issues associated with other craft-based creativity.

For those with limited time to commit to their art, sketching is probably the most productive and enjoyable option. The time-starved artist can be confident that sketchbook endeavours will provide the best education and introduction to the essential principles required to produce convincing paintings, should he or she choose to turn to the brush once they have more time.

Consider the fact, too, that once you become a 'practitioner of the pencil', waiting for trains, planes, and your children will become a pleasure, not a chore. You will be celebrating such delays: though don't get too ecstatic or you may find yourself blamed! Sketching is also accessible to all, which makes it ideal for spending time with your family. If my experience is anything to judge by, you will find that once you commit to the pencil, your children will too – usually the exact pad and pencil that you are using.

What is the difference between sketching and drawing?

A student once asked if I sketched or drew. I had never really thought about it, but now my editor is asking me the same question! For me, the devil is in the detail. A drawing is a more technically accurate, finished, refined piece of work; a sketch, on the other hand, is a looser, more immediate, often frantic attempt to capture atmosphere or movement.

Of course, there is a lot of crossover. Some people naturally draw very tightly and long for a more loose, sketchy style, while others – perhaps due to a lack of drawing ability – work far too loosely. Practising one's sketching is a solution to both problems.

I often find that studio sketches start to become drawings as I spend more time on their execution and the rougher edges get knocked back. Volterra, on page 20, is a good example.

The technical eye and the emotional eye

The thing that drives us to sketch, even as a novice, is emotion. Indeed it could possibly be said that emotion is the driver of all creativity. As a youth I fell in love with the electric guitar and managed to purchase a cheap guitar and amplifier. I was still living at home at the time and it's no exaggeration to say that my father made at least three attempts on my life – during any given practice session. I worked out some years later that the cause of the rupture between father and son, was that said son was in love with the guitar... but could not actually play it.

The point I am making here is that in craft-based creativity, emotion without the technical skill to express it is all noise and no tune. A pencil is a much simpler tool than an electric guitar; but diligent study of the techniques involved is still needed to give you the ability to sketch as you wish.

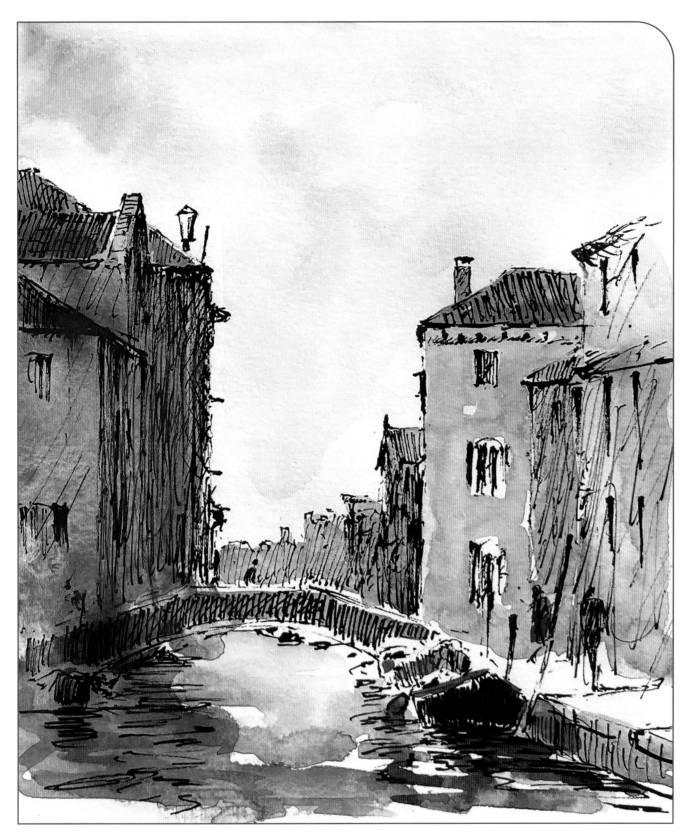

Near the Ghetto, Venice

A pen and wash doodle of a quiet Venetian backwater. There has to be an emotional reason to a sketch. If the artist is not well-versed in the methods of drawing and sketching, the technical challenge will often get in the way of this vital emotional response – so building your technical skills will help you to sketch how you want to.

Outdoors or indoors?

If you are intending to sketch the landscape, the question immediately arises: is one allowed to use photographs and thus work indoors? Or should even the novice brave the elements, onlookers, insects, changeability and various bits of animal waste, to sketch 'for real', so to speak. The answer is probably neither a definitive yes or no but rather: 'it depends'.

It is true that there is no better experience to be had than to sketch a perfect subject, in perfect weather in an undisturbed location outdoors. It is also true, of course, that this rarely happens.

Choosing whether to sketch on the spot or to take a photograph for later reference is down to certain factors, such as the individual artist's level of competence, the busyness of the location or scene, and the weather.

While photographs can be a useful support to your sketching, I warn against using them as your initial approach to a scene. Once you make a habit of taking photographs, you sketch on the spot less frequently, your work becomes less exciting, tighter and less free. (I haven't yet seen a case where your friends leave you; and you start wearing clothes with food stains down them, but that seems a logical extension.)

In allowing photographs to become your first port of call, you risk throwing away the best experience of all – that is: of being out there, living the thrill and excitement that is outdoor sketching. Let me conclude by giving my own personal reasons for sketching in and out of doors.

Indoors

Sketching from photographs is not 'wrong', and certainly has its uses; but in my opinion it is a poor substitute for actual on-site, in the moment, sketching.

If, however, time is very pressured then I will take a photograph, or try a very quick scribble backed up by a photograph. This is a good use for a tablet as opposed to the smaller screen of a phone or camera: if you have a spare moment later in the day, you can render a sketch from a reasonably-sized image while the 'spark' is still fresh in your mind.

Sometimes, particularly on flatly-lit days, I may see a scene where the shapes look interesting but I can't develop a plan or purpose to focus a sketch on. At such times, I may take a photograph to consider the scene in more detail later.

Another use for a photograph will be when things are fleeting, such as extreme and short-lived weather effects, or when travelling on a bus or train and something catches your eye as you pass. I also believe that some of the best views are from the middle of the road, or on private property, where a quick snap may be all you have at your disposal.

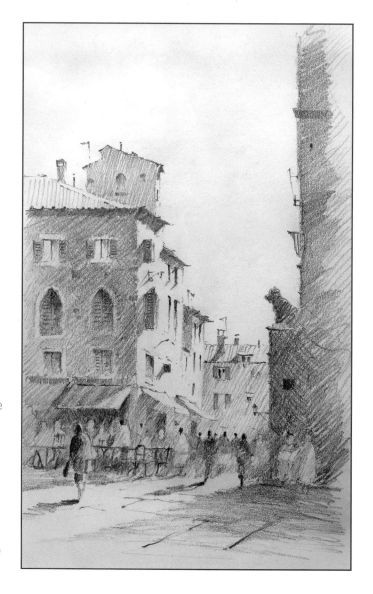

Indoors: Volterra

This sketch would have been an utter pleasure to carry out on site, but time pressure and company meant that a quick photograph was all I could hope for. It was carried out at home in the studio, and so I had a lot more time to rearrange bits and add more little details than usual. As a result, the level of finish almost makes it a full drawing rather than a sketch.

Outdoors

Sketching indoors feels clinical and restrained compared with the outdoor experience. Some days I go out with the sole purpose of sketching. A small bag to hold a sandwich, flask and sketchbook is all that is needed. You don't have to dedicate a whole day: sometimes I will nip out for an hour to grab a quick sketch, much like an athlete would to do a short run.

It is the whole process of sketching outdoors that is so satisfying. There is the fresh air and the walking as you search for a subject. Then there is the thrill of spotting something promising and then the fight to get it into the bag, like a fisherman landing a trout. (The last time I went fishing was just before I started playing the electric guitar, and the only thing I managed to catch with my hook was the scalp of my long-suffering dad!) The concentration involved, along with the sounds of the world around you, make for a sublime experience, even in a city.

The urgency and immediacy of working outdoors produces a steeper learning curve and often a looser sketch that is more alive. It helps us get to the essence of a scene quickly and we 'commune' with the scene as we chase it onto the paper.

Shyness and inexperience are no excuse for not working outdoors. We can go out early, to the quieter places, or sketch from the car if a viewpoint can be found.

Outdoors: Sunlight bird rock

The birds on the rock were making a cacophony of noise as I leaned on a gate to sketch this one warm summer afternoon. There were buzzards and kites circling on a thermal, perhaps looking for chicks to steal.

As an illustration of one of the drawbacks of working purely from reference images; I had taken a photograph to back up the sketch – but when I came to look at it, it had blacked out all the shadow areas, leaving no detail or subtlety in the darks, as a camera often does.

Tip

Besides going out specifically, you can often spot potential subjects in passing or while you are generally out and about. This is why we should always carry a sketchbook.

Making a start

I once had a student who had never sketched prior to the class, and had bought photographs of their trip to Barcelona from which to work. The images were full of complex but beautiful architecture that would have given even Rembrandt pause for thought. Once I had got back up off the floor and the colour had come back to my face, I asked him the reason a novice would attempt such a thing. 'It was a great holiday,' he replied.

There are many reasons for choosing a given subject and unfortunately, for the novice, technical ability is one. We need to start with subject matter that will lead us gently into the skills we need to hone. Initially, we need to keep it simple with a few shapes, flat-on.

This means that you should be looking for subject matter with three or four shapes, not fifteen. Try avoiding complex perspective too, as you start out. Buildings that are flat-on can be easily reduced to simple shapes such as squares, rectangles and triangles; giving you good practice and building your confidence for later, more ambitious work. Look for a good tonal range to help you with hatching and using light and dark tones. As we progress, we will feel more confident in adding additional shapes or trying a bit of perspective.

Perspective

It is easy to get bogged down in the technical side of perspective, so I recommend simply relying upon observation of lines. In short, lines that travel away from us, into our pictures, obey the rules of perspective:

- *Lines that travel away from us and are above our eyes, come down towards the horizon.*

- *Lines that travel away from us and are below our eyes, come up towards the horizon.*

I simply hold my pencil out in front of me and place it along the line. This will tell me if the line is sloping up, or down, as it travels away from me.

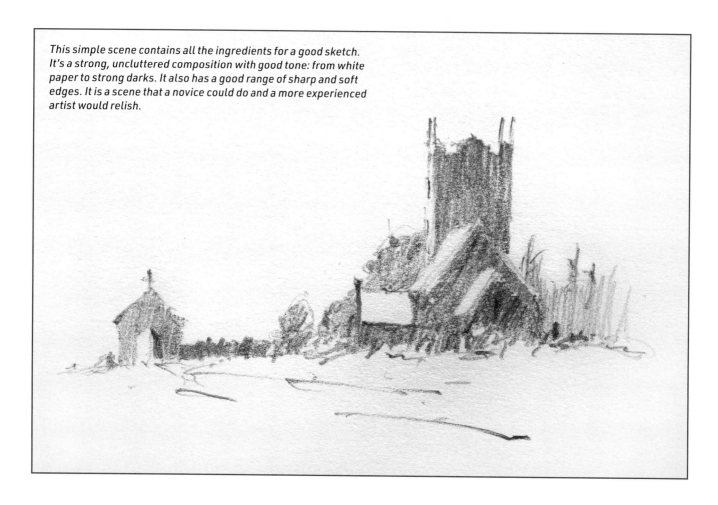

This simple scene contains all the ingredients for a good sketch. It's a strong, uncluttered composition with good tone: from white paper to strong darks. It also has a good range of sharp and soft edges. It is a scene that a novice could do and a more experienced artist would relish.

How to hold a pencil

The way that you hold your pencil is personal, but it will have an influence on the marks you make. Shown below are three different ways to hold a pencil, depending on the task at hand.

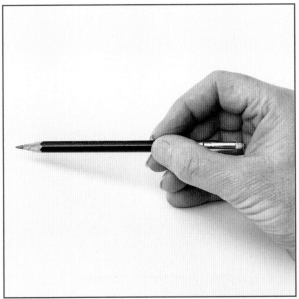

Long and loose

I use this the most. The pencil is held in a loose manner, well back along its length. This grip will allow you to vary between long wandering lines or faster 'struck' lines, simply by pulling on the fingers.

It's ideal for initial construction lines and getting the 'feel' of a scene – that is; the big shapes. If used lightly, then no eraser is required as errors can be left: this often adds energy to a sketch.

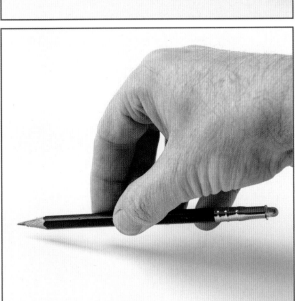

Charcoal grip

I call this a charcoal grip because it's the way I would hold a stick of charcoal to produce broad sweeping strokes. It's a useful way to hold a pencil when working on a larger scale because it allows us to sketch from the shoulder, rather than the wrist. This allows us to produce larger, looser marks than the other grips mentioned here.

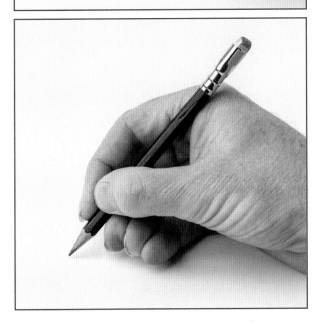

Close and firm

This is the way a nervous novice holds the pencil, and it's a disaster. This grip creates heavy, tight, insistent lines, usually accompanied by liberal attacks of the eraser.

Nevertheless, this position does have some redeeming features. Holding the pencil in this way can be used for very dark tones as it allows you to add a great deal of pressure. This is useful for achieving heavier tone through hatching and for the darkest darks in your sketch.

The role of the scribble

You will be surprised how the things you draw can be represented by the most simple and abstract of marks. Here we have a bush, a crowd and a tree, all started with simple scribbles.

If you look through the sketches in this book you will be surprised how the humble scribble pops up again and again as a starting point for various objects and passages.

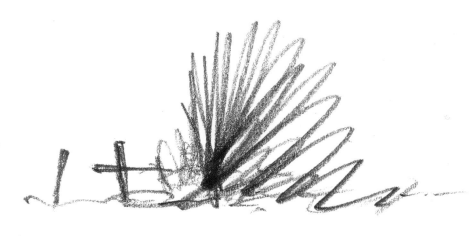

Accompanied by some straight lines to hint at fenceposts, and a loose, wavering horizontal, this scribble resolves itself into part of a hedgerow.

Scribble sketch: winter trees

Try this exercise to see how the humble scribble can be used to quickly render winter trees with a layered approach.

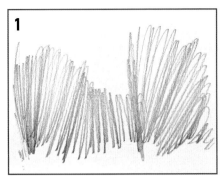

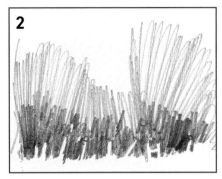

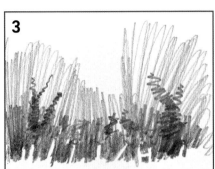

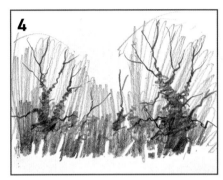

1 Holding the pencil with medium pressure, lay down a few fan-like scribbles with the pencil on its side and in continuous contact with the paper.

2 With firmer pressure, lay a darker scribble at the base. Cut around fenceposts to break up the bottom edge and add scale.

3 Changing your scribble from vertical to horizontal and pressing quite hard, suggest the ivy-clad trunks of the trees.

4 Using the point of the pencil, suggest a few individual branches and twigs.

Tip
In order to use scribbling to suggest and simplify complexity, you have to concentrate on achieving the correct profile (outside edge) as this is the key to producing a believable shape in the eyes of the viewer.

Scribble sketching in practice
In both of these little sketches, the background trees have been reduced to a fan-like scribble. This simplifies the sketch considerably and allows the nearer trees to stand out due to their stronger tone and increased detail.

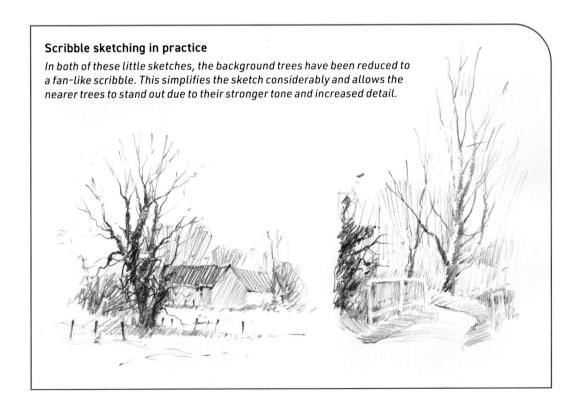

Taking a line for a walk

If you were sitting in front of a scene and you had to take your pencil for a stroll across the paper in one continuous line, what route would you take?

The junction between land and sky will often be prominent in a landscape and this is a good place to start. Once one's eye is tuned in to what I call 'dominant horizontals', they will start to appear in virtually all compositions.

Shown are a few typical examples of how much can be suggested with just one line. I start busy sketches in this manner very often. Give it a try yourself on a nearby scene.

A small summer tree with houses and a church.

Boats up against a harbour wall; the latter suggested by the base line between the boats.

A lighthouse, cliffs and sea with boats.

The side of a busy street and some cows.

26

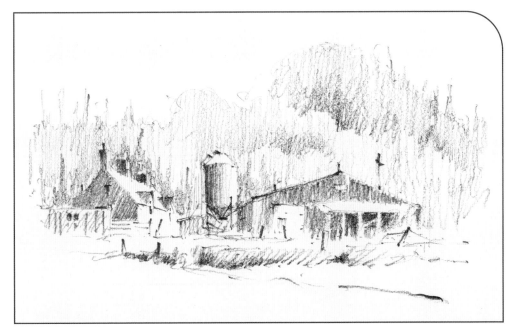

Hall Farm, Crickhowell

Think of a straight line as the most boring profile possible, and compare it to the profile running over the house, silo and barn. I'm definitely not the only artist excited by a good profile!

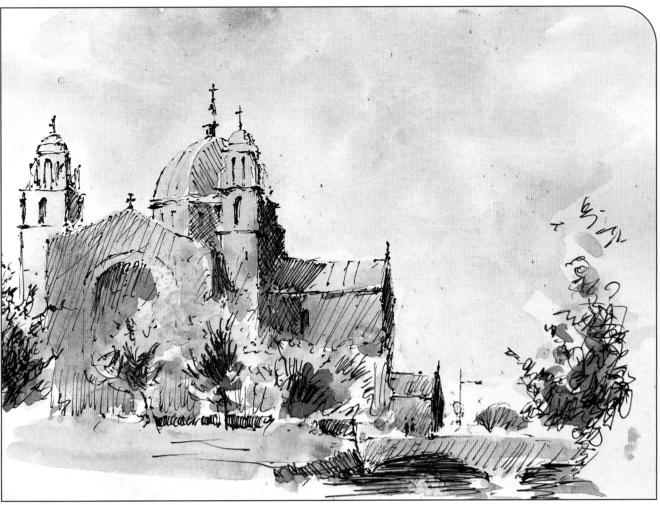

Galway

A rapid sketch of the cathedral in Galway, Ireland, where the dominant horizontal that formed the sky/land partition was a critical part in the initial mark making for the sketch. Once this was complete, and checked for accuracy, I could flesh out the shapes below in more detail.

Farm in Sunlight

Here is an old farm on the Orkney Islands, Scotland. It was the dark shadow and the profile of the house that made me stop and take this photograph. I would not like it as much if the house were not there. It is a subject that should be suitable for the novice as there is virtually no perspective, reasonably simple shapes and good tone. It is a subject that allows us to put into practice the ideas on the previous pages.

I am going to sketch the whole thing but the house and part of the barn would make a good subject too, as would the other barn end. I will shorten the middle barn though, as I think it is too long – such architectural changes are well within the power of the artist!

You will need:

Paper: sketchbook or a piece of cartridge paper

Pencils: 3B graphite pencil

Source photograph

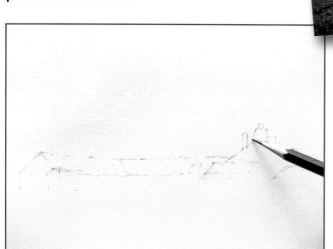

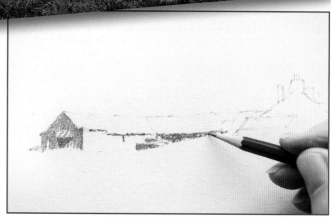

1 Hold the pencil long and loose and move from left to right, along the roof line and under the gutter line. The line should be light, but don't be hesitant: errors will occur but they can be corrected. Can you see where I have corrected the lines above?

2 Check the initial light lines to make sure that you are happy with the initial shapes. I already know my next step because I 'drew it in my head' first: shorten your grip on the pencil and set off from left to right once again, this time placing the shadows. Leave the little gatepost as a negative shape.

Negative shapes

When we are shading in a dark-toned shape on white paper or over a previous lighter tone, we have the option to shade around any lighter shapes, thus pushing them forward. These are called negative shapes because they are formed by the shading that we put behind/around them. So they are not 'drawn on' but 'pulled out' by this darker tone.

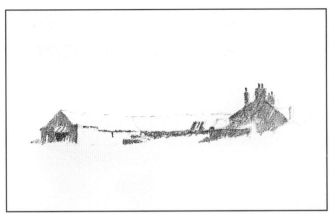

3 With the shadow in place, develop darker accents inside the barn and on the chimney pots by working over the areas once more with the pencil. You may decide to work over some of this again later, but it's fine for now.

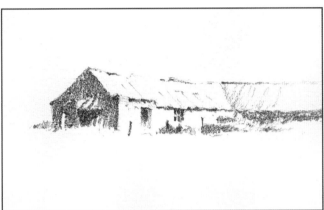

4 Starting on the left once more, its time to suggest detail like roof sheets and windows. Place the shadow of the lower foliage, too. Continually alter the pressure on the pencil to get lost and found lines. Press really hard to get good dark accents for areas like the windows.

Lost and found

Do notice that the roof line is very lost and found – that is, the line varies in strength and weight. A hard continuous line here would look completely wrong – no doubt the farmer would send us packing once he'd noticed it!

5 Place the hedgerow next. Note that the gap of white paper is important to represent the sunlit nature of the scene. Shade the dormer roof lightly and add the telegraph pole to echo the chimney verticals.

6 Give an indication of the foreground grasses with a few horizontal scribbles, and link these to the farm with some fenceposts. Finally, further darken the house gable to help lead the eye to this end of the sketch first.

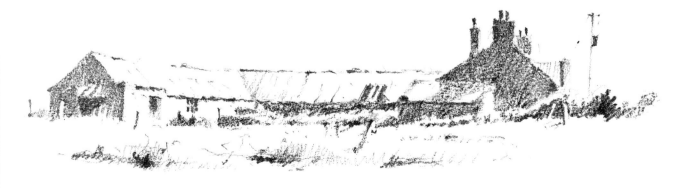

Seeing the world

You may be surprised at this, but this part of the book is one of the most important. If you can re-train your brain in the manner suggested by this chapter then you will progress in your sketching at a startling rate – provided that you put in the practice, of course.

I accept no blame if your new, very strange take on the world results in you getting funny looks from your friends; but if it does, console yourself that it will give you an excuse to ditch them and practise!

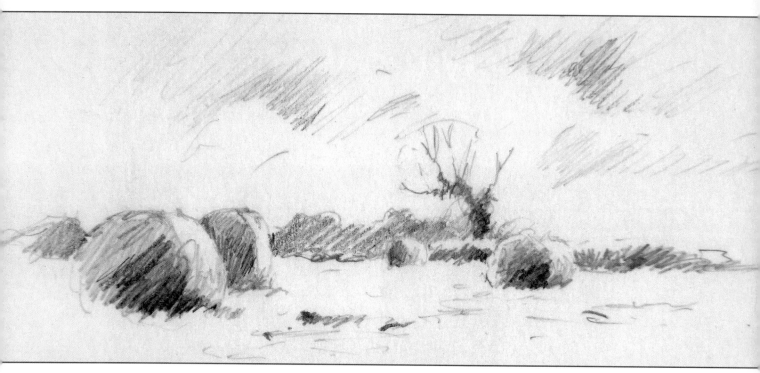

■ S.E.T. – Shapes, edges and tones

Have you ever considered that perhaps one of the reasons that you find drawing things like trees, houses and boats difficult is because you see them only as trees, houses and boats? This is fine for everyday purposes, but is nowhere near good enough for sketching them.

An experienced artist is obviously still aware of what the object is, but will put this knowledge to the back of their mind. Instead, they will primarily be scrutinizing the object for the combination of shapes, edges and tones that make up the object. I call this S.E.T.

To sum up, we need to stop seeing the world as a layperson and start to see it as a pencil-person. Where a layperson sees objects like trees, buildings and cars, the pencil-person sees shapes, edges and tones.

The following pages break down S.E.T. into its three component parts of shape, edge, and tone and explain how to see and use each element.

Tree and bales

Haybales, hedgerows and cloud forms? No; just shapes, edges and tones. Everything you see can be simplified to these three core areas.

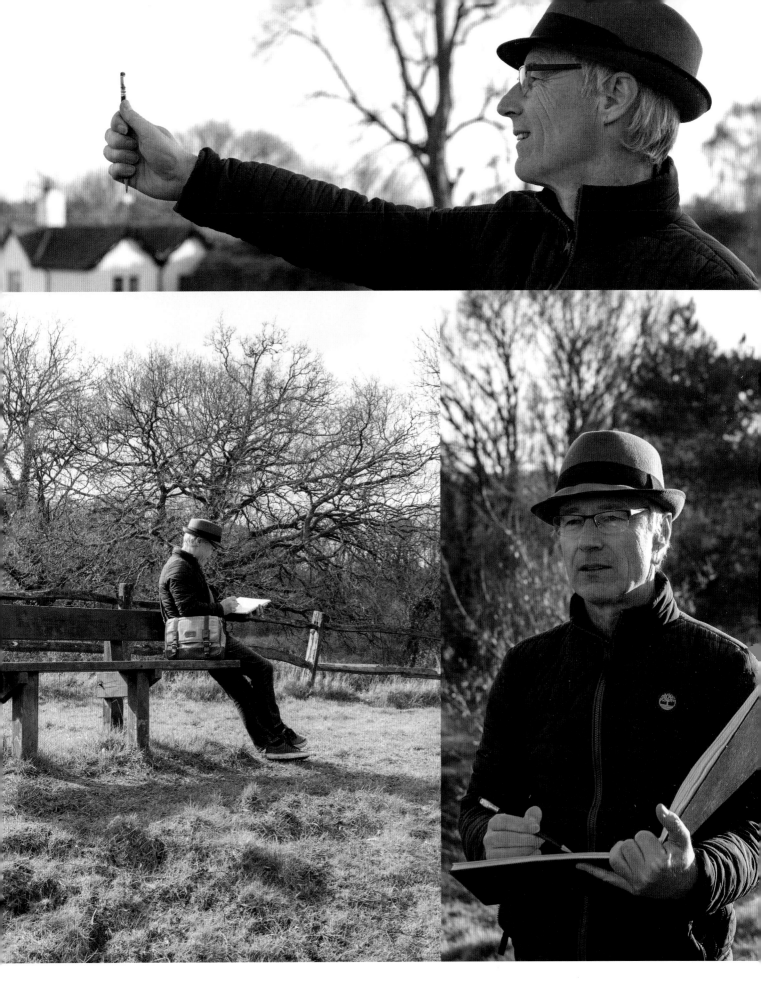

SHAPES

To the artist, objects become simply shapes. These shapes do not have outlines, but they do consist of edges and tones. This will all become very clear by the end of this chapter, so let's start by looking at what shapes are, and how to draw them accurately.

A shape may, and often does, contain many objects. That is, objects can and often do combine and merge into one big shape – as you can see in the misty landscape to the right. Try squinting to help resolve a mass of objects in front of you into fewer, bigger shapes.

Here we look at ways to identify what shapes to use, how to place them accurately, and – very importantly – how to check for errors in proportion and placement. A useful saying to bear in mind here is 'make a shape, check a shape, tone a shape'.

See how colours are muted, shapes and edges fuse but a good range of tone still exists.

Venetian Square

Here is an example of placing big shapes. This sketch relies on two big shapes for its effect: the skyline and the crowd line. Notice, too, how the scribble technique that we discussed earlier has been used for the crowd.

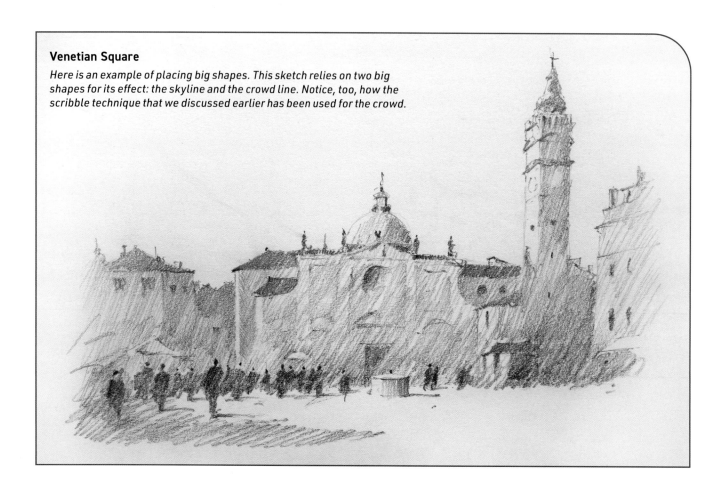

Drawing shapes

Shapes of one sort or another are often the first things to be placed at the start of a sketch. Remember that we treat objects and parts of objects as shapes. Remember also that a number of objects may combine to form one big shape. While it is important to recognize shapes, it is equally important to be able to place shapes with reasonable accuracy, both of the shape itself and its relationship with its neighbours.

Big shapes

We always place the biggest shapes first. It is very important to be aware of the big shapes in a composition. The novice tends to get utterly lost in often unnecessary detail, only to collapse from exhaustion well before the sketch is complete. You will never be able to sketch complicated subject matter, such as street and harbour scenes, if you can not simplify the subject into one or two big shapes prior to adding only necessary detail.

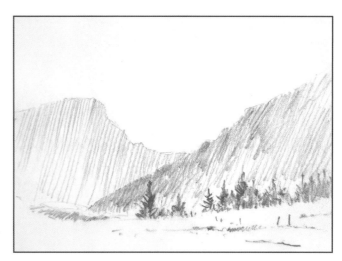

Big shapes
Here three big shapes are used for the mountains and tree line, after which very little detail is required.

Simplify

A lot of folk today feel that life is too complicated and they long to simplify their life by reducing clutter and unnecessary things. What a lovely analogy for the way that we should approach our sketching. The world is a complex place and when we like a part of it, we focus in and our peripheral vision becomes blurred with much less detail. To achieve this with a pencil, we must remove unnecessary clutter. We must combine and simplify areas, especially in complex scenes such as townscapes and rock faces, for example.

We achieve this simplification much more easily if we start our sketch with big shapes and resist the urge for detail at too early a stage. The simplification of peripheral areas plays a huge part in amplifying the focal point or 'message' of our sketch.

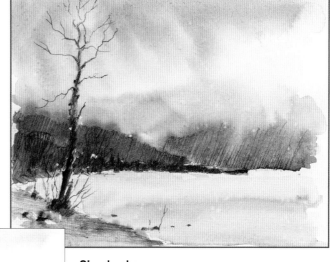

Simple shapes
Sometimes very little detail is required and a few simple shapes will suffice, highlighted in the detail to the left. I will often put a wash of watercolour over such sketches as they are usually about atmosphere and a wash helps to achieve this.

◼ Reflex drawing

I tend to use light lines to construct my shapes. These lines are often lost in the finished sketch once the shading is applied. For smaller shapes and more abstract shapes – like bushes, for example – I will go straight in with shading alone as lines don't really seem apt. For some artists however, line plays a much greater role. We often see this in life drawing and cartooning, for example.

Reflex drawing is interesting to try. It involves drawing the outline of the object you are sketching, quickly and in one continuous go, without taking your pencil off the paper. Some artists specialize at this and it is a speedy way to do rapid exploratory sketches.

This technique has the advantage of being very quick indeed. It is excellent for working in busy towns and cities, as it will let you gather information swiftly.

This sketch was made in under five minutes; it records all the key shapes, allowing for later development, if you decide to return when you have more time.

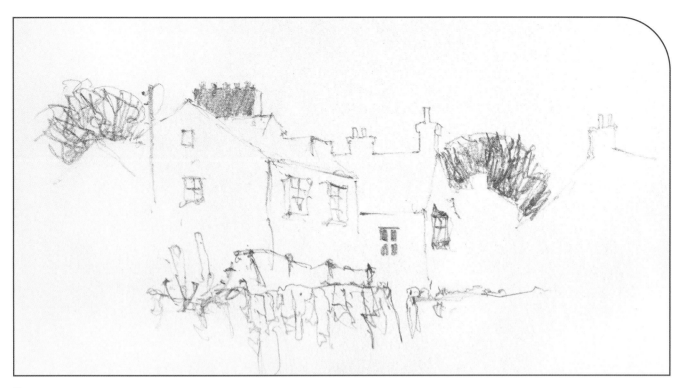

Parrog

Made with the reflex drawing technique, here I held the pencil loosely and drew while looking continually at the subject, only occasionally glancing at the sketch to check progress. This approach works better with experience and results in a pleasingly loose, compositional type of sketch.

Holding the pad out

Draw a shape lightly in your sketchbook. Then hold your sketchbook up in front of you at arm's length so that you can see both the shape and the object that you are sketching. Now that you can see them both in the same eyeline, you should be more able to spot errors easily.

This is one of the methods I use most during the early stages of a sketch. Novices may prefer to make more frequent measurements using the techniques on the following pages, but as we gain experience, holding the sketchbook up should suffice for all but the most difficult of objects.

Ghost lines

Ghost lines are imaginary lines that help us to relate the position of one shape to another. Do not be afraid to very lightly draw some of these ghost lines onto your actual sketch if this helps in the placement of shapes.

These ghost lines also create negative shapes that further help us in our quest for accuracy. I will often physically hold my pencil out in front of me and place it across gaps between shapes to help me see the negative shape. There are also shapes between shapes (between two windows, for example) and these help us with placement accuracy for the shapes that they come between.

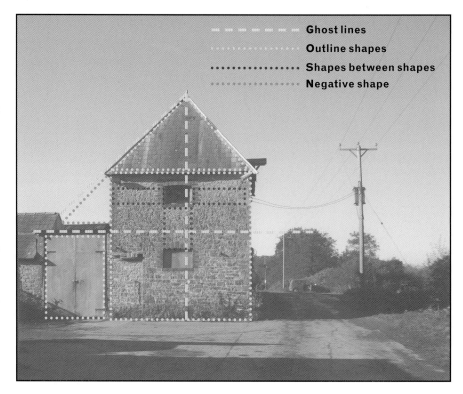

- - - - - Ghost lines
············ Outline shapes
●●●●●●●●●●●● Shapes between shapes
············ Negative shape

Llantwit Major

A complex scene such as this involved constantly holding out my pencil to form ghost lines to help me place the relative shapes. This helped me notice such things as the fact that the roof of the church is the same height as the left-hand side chimneys and the car was directly below the corner of the church roof. This continual cross referencing is essential if we are not to go widely wrong.

Checking angles

When faced with sloping lines in a composition I will once again hold my pencil up and tilt it until it matches the slope of the line. This gives me an approximation of the angle I need. I will then usually place the line on the sketch pad and hold my pad out to see if it looks right.

Buildings like this are full of complex interactions of angles and lines; but you can simplify things by checking them one by one with this technique.

Newport Rain

The angles of the roofs, windows and awnings all vary in this street scene. To sketch such scenes accurately, it is important to check the angles.

Sight sizing

We can use our pencil to measure objects. This is said to be drawing 'sight size'. We can then take the size of an established object and measure how it compares with others.

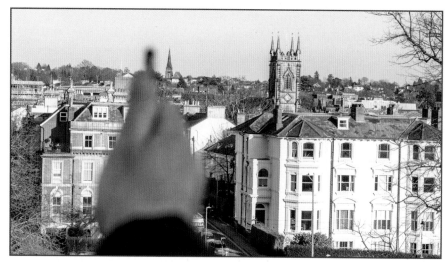

1 With part of your sketch in place – here I have laid down the dominant horizontal of the distant skyline – hold the pencil out at arm's length. Close one eye and align the end of the pencil with a prominent area or object that you have drawn; in this case, the spire of the distant church. Next, place your thumb at the base of the object (i.e. the spire).

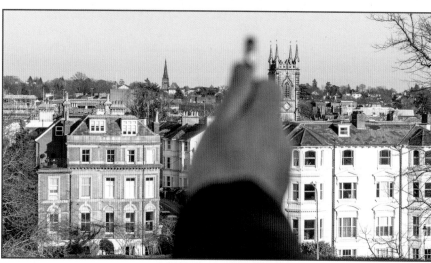

2 Here, I want to find out how much bigger the church tower in the middle ground is than the distant spire. Keeping the thumb in place and arm outstretched, swing the pencil over to the other object and align the end of the pencil with the top.

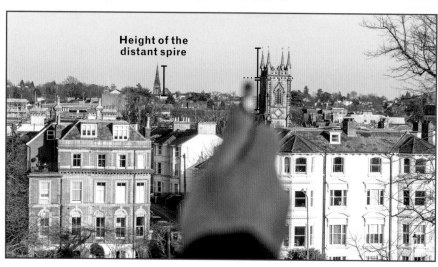

Height of the distant spire

3 Making a mental note of where your thumb sits on the object (the dotted line here), move the end of the pencil down to that point. This reveals that the distance from the top of the church tower to the clock appears approximately twice the height of the distant spire.

Scale sizing: training your eye

If we wish to draw larger or smaller than sight size, we simply use the real chimney to measure our real house, and our drawn chimney for size comparisons on our sketchbook. This is called scale sizing. This method can be quite long winded but in time, as you develop and practise the technique, you will be able to measure shapes by eye alone.

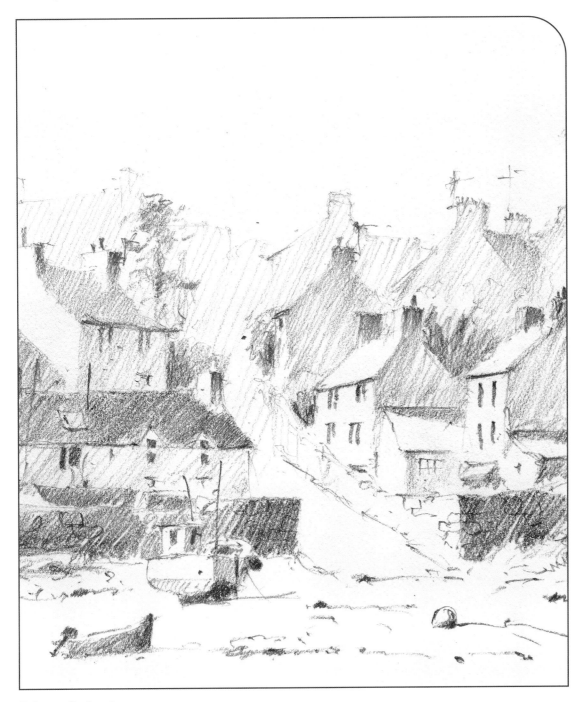

Brittany Backwater

The sketching of this little scene involved a lot of the techniques that we have already discussed, such as sizing objects, establishing dominant horizontals, and using lots of ghost lines to compare things and create negative shapes.

Incidentally, the composition appeals due to the repeated gable ends – that is, repetition with variation. This is a very effective compositional tool to which we will return later on.

EDGES

Nature contains no lines, only edges. Edges exist where different tones meet. On clear bright days shapes will have strongly contrasting tones and will stand next to each other with hard, defined edges. Consequently, on more hazy days, the same shapes will be less contrasting (closer-toned) and will merge gently together with soft diffuse edges. The examples opposite show how the same scene can be approached in different conditions.

 Once we understand the character of the edges in a scene (and how to render them with a pencil) we are much more able to produce a sketch with atmosphere. Where a novice would simply draw a house, due to our knowledge of tone and edge, we shall be able to draw a house in sun or rain or mist. The first time that I achieved this I was so pleased, I was stopping the traffic to show them what I had discovered (most seemed more bemused than impressed, to be honest).

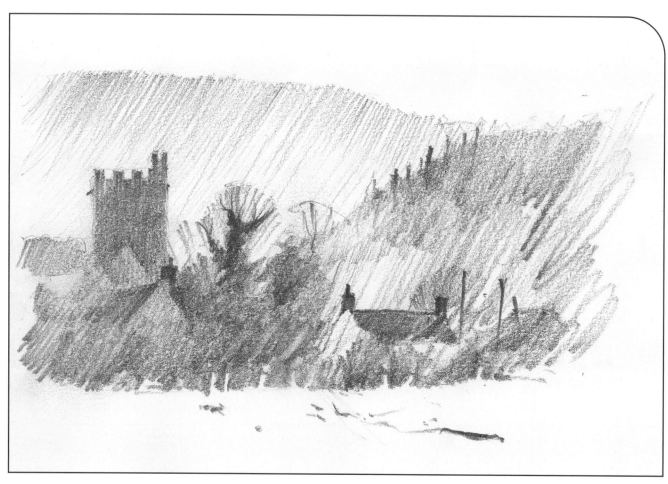

Llanover

The tops of the church, tree and chimneys are hard-edged and quite darkly toned. These are the areas that I wanted to draw your eye to and this is why they have been treated this way.

Below the roofline however, the shapes, although quite strongly toned, have been joined or kept very diffuse and soft. This gives them just enough edges to suggest form, but means that they don't compete with the tops of the shapes.

Hard edges

A hard-edged approach to the scene, with dark sharp edges and more separation of shapes.

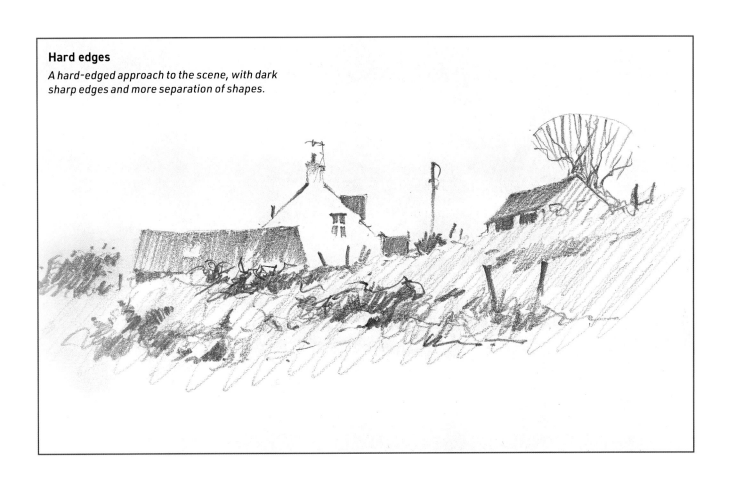

Soft edges

A soft-edged approach to the scene with lots of close tones and joined shapes.

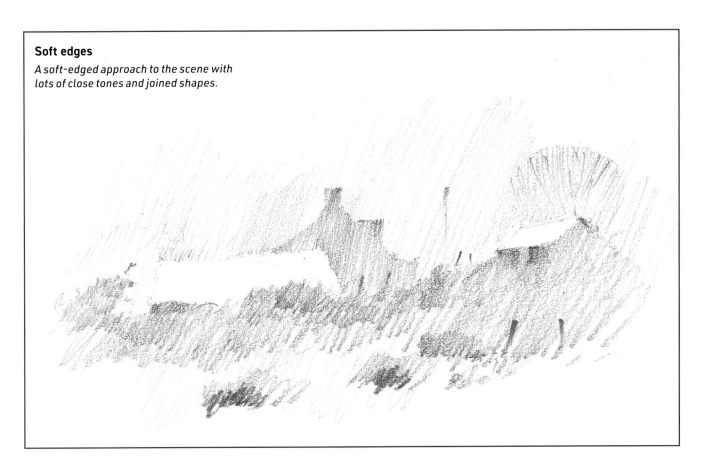

TONES

There is a saying in the world of landscape painting that goes 'colour gets the credit, tone does the work'. With a pencil, we have no colour so tone is definitely king. A sketch without tone is a weak, insipid, grey beast that will utterly fail to inspire either artist and viewer.

In every sketch we produce, we must look for our lightest lights (for this we use white paper) and our darkest darks (the strongest tone our pencil will make). This is how the human eye sees the world. Even on a misty, rainy day, when most of the tones will be middle tones, there will still be some lightest lights and darkest darks. You can practise seeing this range of tones from lightest to darkest anywhere and anytime.

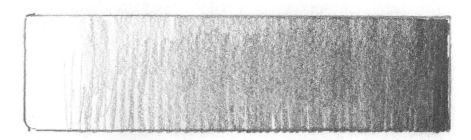

Tonal range
Here is the range of tone available to me with a 2B or 3B pencil. The harder you press, the deeper the tone. Every sketch should have this full range of tone. How much light and how much dark is in each sketch will vary, with different combinations for different moods.

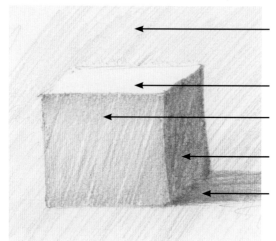

The background has been placed as a light/midtone to help the white top of the cube to 'read'.

The white of the paper is the lightest tone we can create.

This midtone was created with a medium-strength hatch

More pressure was applied here to create a darker tone for shadow.

The cast shadow is dark near the cube, and becomes lighter in tone further away, in a gradual gradation.

A cube
Here is the tonal range applied to a simple cube.

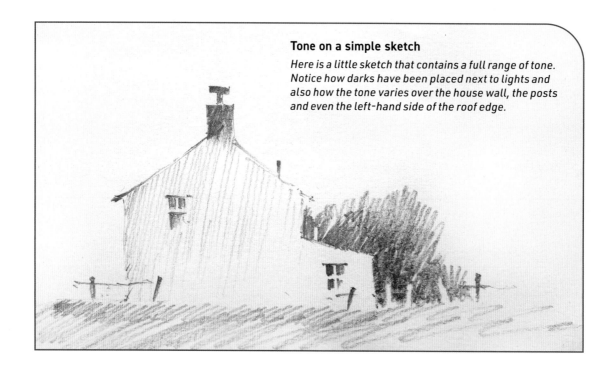

Tone on a simple sketch
Here is a little sketch that contains a full range of tone. Notice how darks have been placed next to lights and also how the tone varies over the house wall, the posts and even the left-hand side of the roof edge.

Hatching off a line

Tone is rendered in a sketch by a process called 'hatching' or sometimes 'shading'. It's really a more disciplined form of colouring-in. My personal preference is for a disciplined hatch (though I will scribble if the sketch is very urgent) so I tend to hatch in one direction. I am right-handed so my hatching normally leans from left to right slightly.

Here are a few tips to get you started, but if you already have your own way of doing things that works for you, then don't change just for the sake of it: practise and refine your own approach.

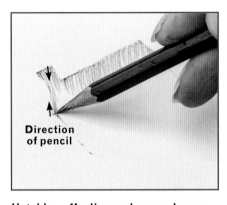

Direction of pencil

1 Place the pencil down onto a pre-drawn line and with a short, sharp movement, 'strike' downwards or upwards as the case demands.

2 Return to the line and repeat, to make a series of parallel hatching marks along the line.

Hatching off a line on larger shapes
The arrows show the direction the pencil takes from the line: downwards from the top line and then upwards off the lower line as shown here. This is particularly useful for larger shapes.

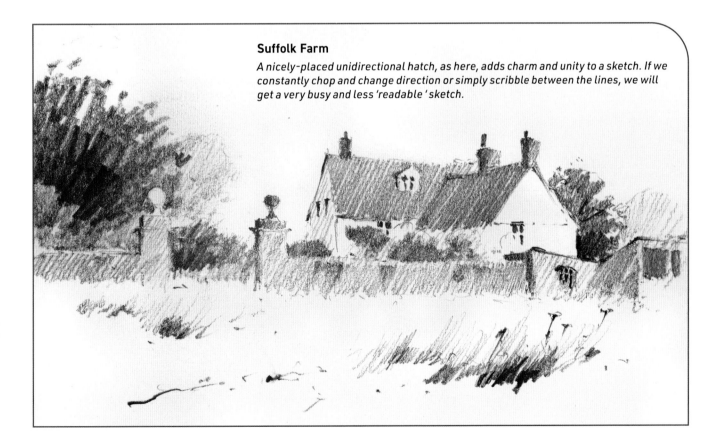

Suffolk Farm
A nicely-placed unidirectional hatch, as here, adds charm and unity to a sketch. If we constantly chop and change direction or simply scribble between the lines, we will get a very busy and less 'readable' sketch.

Hatching large areas

To cover large areas quickly and accurately I will scribble the pencil back and forth continuously while using my finger to act as a stop and guide the pencil along a line.

It takes a bit of practice but is a lifesaver in freezing weather, or when a subject may be fleeting and time is of the essence.

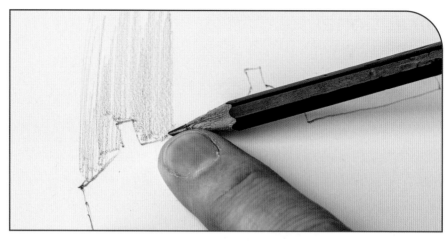

Track your finger along the line as you work, creating a barrier to stop the hatching going over the initial line.

Gradated hatching

Remember that hatching does not have to be all the same tone. Simply by adjusting the pressure on the pencil we can get surprisingly subtle tonal variations.

You can instead swap between pencils to vary tones: the softer the grade (see page 8), the darker the mark; and the harder the grade, the lighter. Personally, I find this breaks the flow too much, and so usually use the same pencil throughout a sketch.

You will need:

Paper: sketchbook or a piece of cartridge paper

Pencils: 3B graphite pencil

1 Indicate the old tin can with a light pencil line. Do not outline the shape.

2 To form the shadow on the inside of the can, hatch from left to right, using vertical lines. Press quite hard initially, then relax the pressure as you travel towards the right.

3 Repeat the same process for the outside of the can. This time, travel from right to left. Don't be afraid to re-hatch areas to fine-tune the shading.

4 To attach the tin to the ground, place a shadow with a horizontal hatch. Aim to get it lighter as it travels away from the can.

Hatching a curve

Gradated hatching can be used very successfully to suggest curved surfaces as shown here.

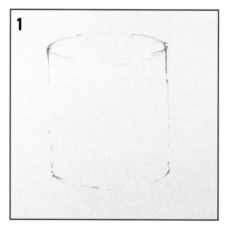

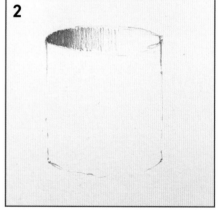

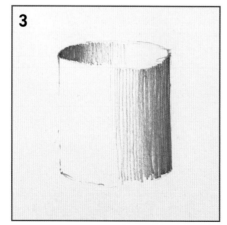

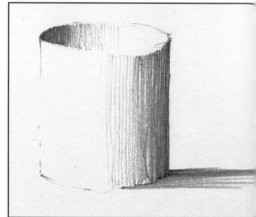

Directional hatching

When directional hatching, our lines follow the direction of the surface that we are hatching: we would hatch with vertical lines for a wall and horizontal lines for a shadow or reflections, for example. This helps to describe the form of the object more readily than simple diagonal hatching.

Directional hatching comes into its own when suggesting form, as on this boat, reflections and shadows.

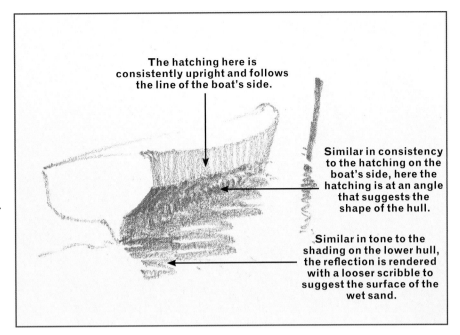

The hatching here is consistently upright and follows the line of the boat's side.

Similar in consistency to the hatching on the boat's side, here the hatching is at an angle that suggests the shape of the hull.

Similar in tone to the shading on the lower hull, the reflection is rendered with a looser scribble to suggest the surface of the wet sand.

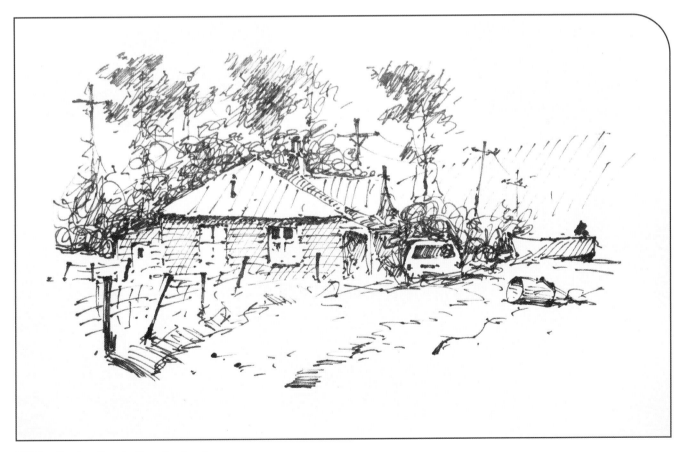

Off the Beaten Track, New Zealand

This rapid sepia pen sketch combines lots of directional hatching with scribbling for the trees. It's rough and ready but has a charm that a more disciplined approach would lack.

Harbour Scene

The technique of looking for dominant horizontals (see pages 26–27) really comes into its own when dealing with complex subject matter like harbours or towns. After lightly placing two or three horizontals, we can often use an overall hatch to start pulling these big shapes apart, and we will be surprised at how much can be left in this simple undetailed state, especially if it is distant or abstract (a grassy foreground for example).

I use this method quite a lot even for simpler subject matter (See *Farm in Sunlight* on pages 28–29). It is important to bear in in mind that even if I do not actually state these dominant horizontals with my pencil, then I will still be very aware of them as I sketch. For clarity in this demonstration, I have made the initial lines darker than I usually would. Lighter lines allow for any necessary corrections and do not insist on the finished sketch so much, so you should use a light touch.

You will need:

Paper: sketchbook or a piece of cartridge paper
Pencils: 3B graphite pencil

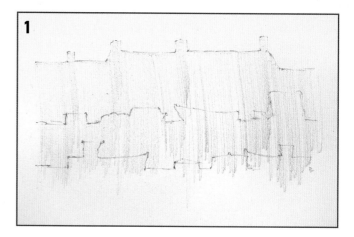

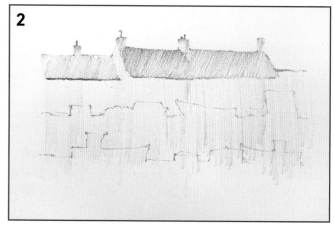

1 Use the 3B pencil to chase in three dominant horizontals – the roofline, harbour line and waterline – by taking the line for a walk as described on pages 26–27. With these in position, place a light hatch through all three areas to separate the land and sky.

2 Draw in the line of the gutters and re-hatch the roof area to pull it away from the house fronts.

3 Hatch in the harbour wall, darker at the bottom and lighter at the top. I suggest you include some, but not all, of the paraphernalia on the harbourside – too much is distracting. I have included one of the boat hulls at water level, but have left the remaining boat shapes as the original hatch to become negative shapes (see page 28).

Tip

To hatch the line of the roof quickly without touching the sky, use your finger to guide the pencil (see page 44).

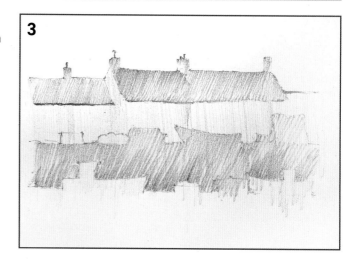

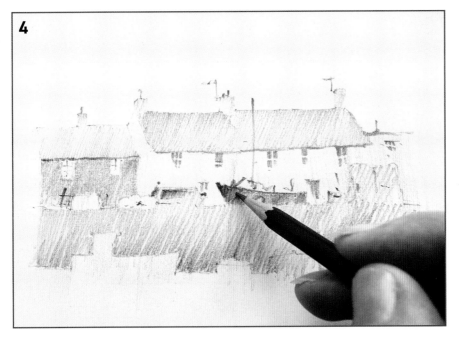

4 The detail can now be added to the houses and harbourside. Darken the left-hand house to push the lighter shapes out. Here, I have rendered lots of these smaller shapes as 'lost and found' (see page 29), and varied the weight on the pencil to make more interesting marks.

5 You can now give the waterline the same treatment as the harbourside, with accents and bits of odd detail here and there. The horizontal hatching on the water here is one of the few times that I use directional hatching in my sketching.

The finished sketch
The three dominant horizontals that started the whole process in motion are now hidden to the layperson but not to you and me, because we look in a different way.

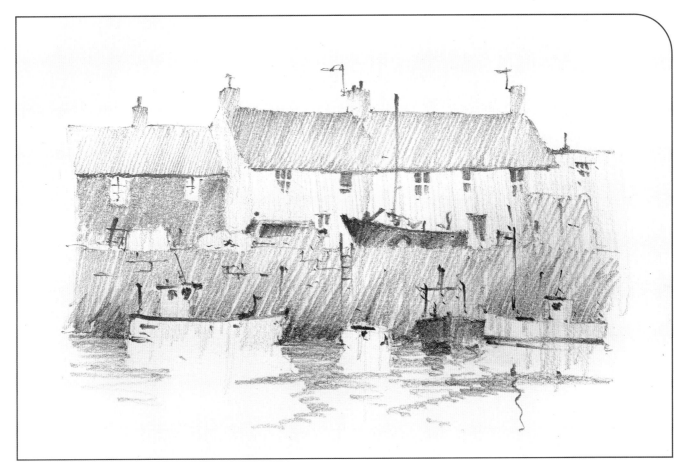

S.E.T. in action

Let's take a look at how the S.E.T. approach – shape, edge and tone –
relates to the real world. First, we will take a look at a finished sketch and its
reference photograph, and then a few exercises, where we can see how S.E.T.
is used in the actual production of a sketch.

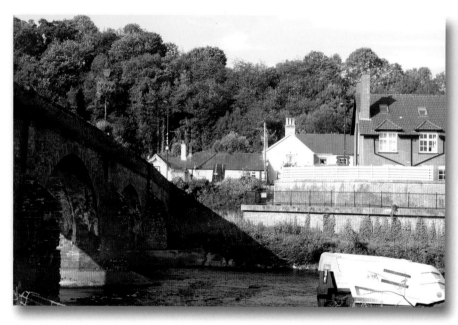

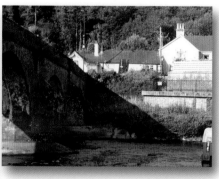

*To the left is the original photograph, and
above is the area that I focussed upon.*

*While making the sketch of this scene,
I must have said 'good morning' about
seven times to passers-by – and deftly
avoided a dog who tried to urinate over my
shoes.*

Usk Bridge

This sketch was produced standing up and leaning against the flood defence
wall. I think it took around twenty to thirty minutes to complete, but definitely
no longer (I would probably have fallen over by then).

 I chose to sketch this because the sunlight revealed a strong composition
due to the bridge, which is a powerful lead in, and the darker trees against
the lighter houses. Notice how the houses are roughly the same shape
(triangles and oblongs), but one is larger. This creates rhythm and pattern,
both of which we discuss in the Composition chapter (see pages 84–97).
I omitted the third house due to its size, and because including it would show
too much of the concrete flood defence.

 Thinking 'big shapes first', I took a light line over the bridge and the
rooftops, checking and correcting errors as I went by using ghost lines
and negative shapes. Then, with this accurately placed, I drew the lines to
separate the roofs from the house walls. With this done I could then isolate
the white house fronts with a light overall hatch. This hatch went through the
trees, roof line, bridge and bank. The big relative dark of the tree mass was
then bravely placed and this did the job of pushing the lit houses into the role
of focal point, due to the big tonal difference and hard edge.

 More line work was then required to make sense of the bridge structure,
after which more tone was hatched in and the details such as house windows
and bushes were added.

Taking a line for a walk over the bridge and houses forms two big shapes that broadly divide the picture in two.

This area of hatching takes in the foliage and shadow on the houses, leaving only soft distinctions between them. Note also that the line of the wall is suggested where it stops at the bottom of the shape.

A combination of hard, crisp edge and big tonal contrast here draws the eye.

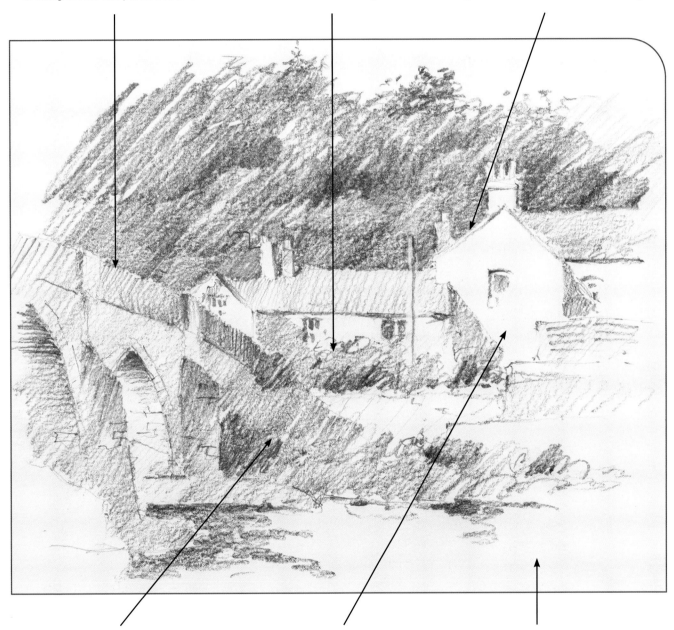

Closer tones and softer edges here combine to form a 'quiet' area.

White paper for our lightest lights, often with a sharp crisp edge too.

The water beyond the shadow of the bridge is left as clean paper. This matches the tone of the houses in sunlight, giving a bright, clean feel to the sketch.

Different approaches with S.E.T.

The sketch of the Usk Bridge on the previous pages shows how you can use and combine the techniques from the previous chapter to draw almost anything. The S.E.T. way of sketching is flexible – the following exercises show a few different ways to use S.E.T. to approach different subjects. They have developed as a way to register quickly the often transient nature of sketching outdoors, where an effect must be drawn before it disappears. Seeing this way also helps in identifying and remembering the salient aspects of a given subject.

Chase the shadows

On a bright, sunny day with lots of strong contrast and good sharp edges, I often concentrate on drawing the linked-up shadow shapes. It's a rapid way of cutting to the chase when the topic of the sketch is sunlight, and avoids the distraction of detail.

This technique is also called a travelling dark.

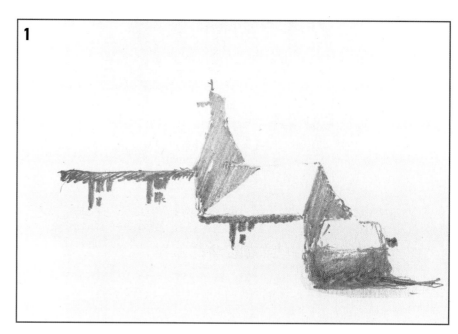

1 Look closely at your scene and identify the largest continuous area of shadow. Use your pencil to hatch in the shape, ideally without lifting it from the paper. The sketch is nearly there, after just one quick step.

2 Add any shadows that do not connect to the largest shadow (here, the door, window ledges, and the rear windscreen of the car) and the sketch is complete.

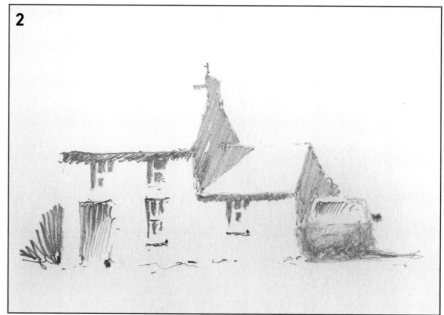

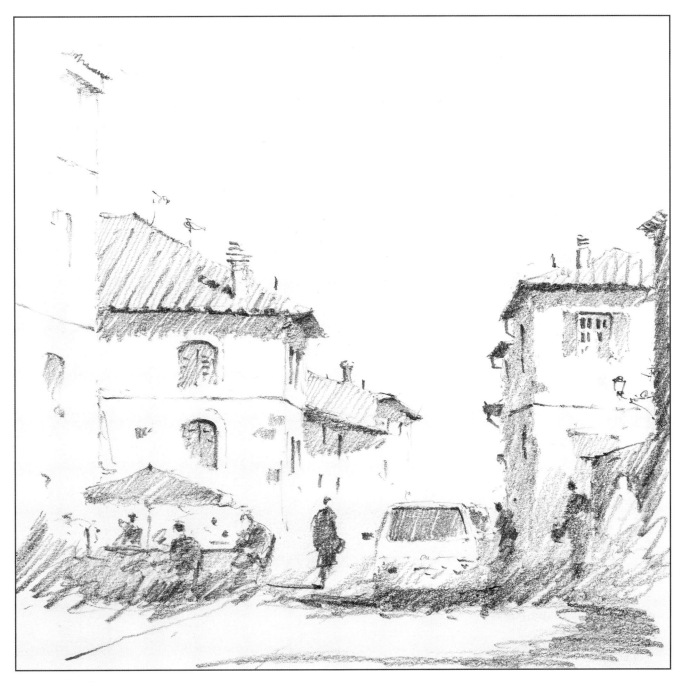

Colle di Val d'Elsa

Had the sun not been out, bleaching out the detail in the light areas, I would not have attempted this scene. Since it is simplified by the bright glare, I have been able to hatch in a few large shadows and the sketch is almost won. All that was left was to add in the dark darks and bits of detail. I do not strive for accuracy in scenes like this, rather I strive to show sunlight.

Isolate the whites

If a scene attracts me due to a bright area being surrounded by closer toned shapes, then I often isolate these light areas to seize the focal point at the outset. I can then develop the initial hatch as much, or as little as I wish.

1 Use hatching to create the negative shapes of two roofs and the top of a car. The hatching all around the shapes helps to isolate them.

2 Use additional layers of hatching to selectively darken the background and form trees at the same time, then add the finishing details to the house with still-darker marks. The original hatch is left for the house.

A Hill Farm

I was partway through sketching this scene when a weak sun broke through the gloom. I immediately stopped what I was doing and placed the big lighter hatch that you can see under the sketch as the first layer. The sun then retreated back into haze and I carried on working up the sketch. If you want light, catch it while it's there.

Overall hatch

On misty, hazy or nondescript days I will often use this method. It's great for times when the landscape is layered and we wish to show aerial recession, for example. It is superficially similar to the isolating the whites method opposite, but the aim here is recession rather than a light focal point.

Aerial recession

Towards the horizon, tones tend to merge together: dark areas appear lighter, and light areas appear darker. This is owing to dust and other particles in the atmosphere. The effect is called atmospheric or aerial recession.

It is due to aerial recession that the lightest lights and darkest darks tend to be in the foreground, while backgrounds are less full of contrast.

1 Scribble over the paper and form the top of the scribble into trees.

2 Place darker pencil work over the roofs, car and windows, then add a bit more detail to the tree line to complete the sketch.

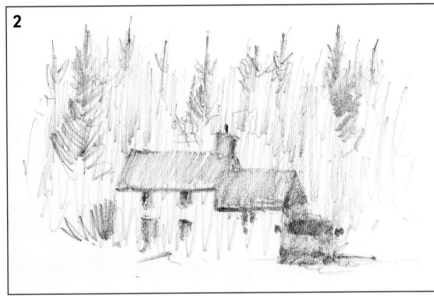

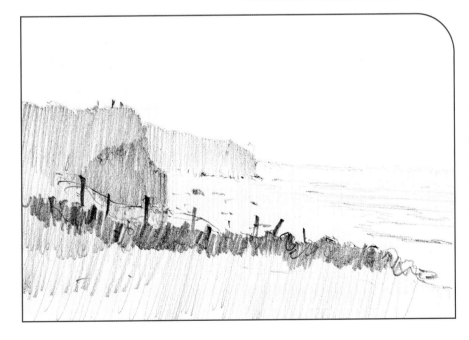

On the Coast

Here is a little 'scribble' sketch that uses the overall hatch technique. The sea and land were first separated from the sky with one big light hatch and the successive darker hatches were used to pull the cliffs forward. It's a good way to create a sense of distance in your sketching.

Combining the techniques: Angus cattle

Take a look at this dear lady, who has been labelled up with the 'shapes' element of S.E.T. to show my thinking as I sketch.

Thinking in oblongs, triangles and negative shapes (formed by imaginary ghost lines) enables us to check the accuracy of our shape-making. The more of these that we can find, the more accurate our shape-making becomes.

Once we start to add tone, we must also become aware of the lightest lights and darkest darks. Here, I hatched behind the cow to establish her back as light. The body received a light overall hatch which I then worked into with darker hatching. As I added the hatching I was asking myself if the edge that I was forming should be hard or soft.

Relax and enjoy; it becomes second nature once you have trained your mind and eyes to look this way, and once you have practised enough, you will be able to tackle any subject.

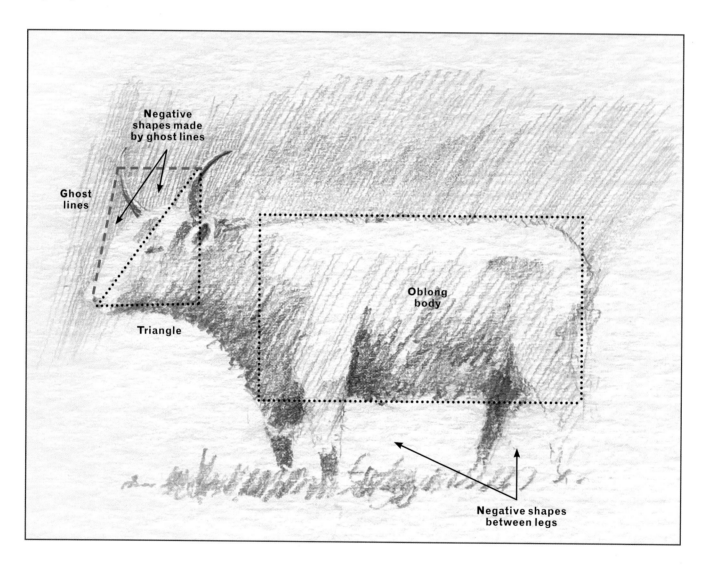

Negative shapes made by ghost lines

Ghost lines

Triangle

Oblong body

Negative shapes between legs

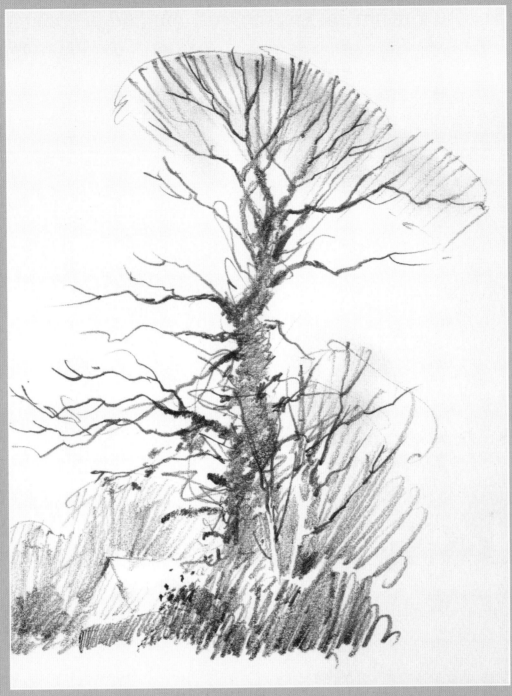

A Winter Tree

While sketching this tree, my attention was mostly focussed on tone and edge quality. In terms of shape, I knew that I would be looking for negative shapes between branches and that the whole tree fitted into a vertical oblong (some trees are wider than they are long, so need a horizontal oblong).

I constantly varied the pressure on the pencil, increasing and decreasing as apppropriate to model the fluctuation in tones. There is a lot of 'scribbling' going on, and I have even smudged my hatch at the top of the tree to achieve a softer canopy. Sketching trees is about getting the 'feel' of the thing; we look at them in more detail on pages 124–127.

Churchyard Scene

Let's sketch this little scene of the church just around the corner from my home. **A bunch of us meet here once a month** where we make music, sing and socialize.
It helps that the canon who runs the church is an ex-punk rocker too.

 My reason for sketching it is the lovely evening sunlight, dark gable ends and the cottages nestling in front of the church. **So, let's see how we apply the thinking of S.E.T. to such a scene.**

 Grab your pencil and sketchbook – but don't be tempted by that eraser; if you use one, I'll find out!

You will need:

Paper: sketchbook or a piece of cartridge paper
Pencils: 3B graphite pencil

Source photograph

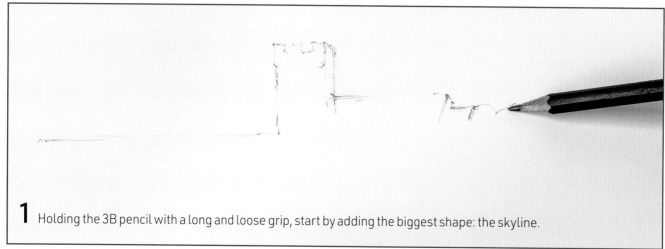

1 Holding the 3B pencil with a long and loose grip, start by adding the biggest shape: the skyline.

2 Add the next largest shape, a big horizontal of the line of closer buildings. Keep the marks light, and relate it to the previous line. Keep referring to your source material to ensure accuracy.

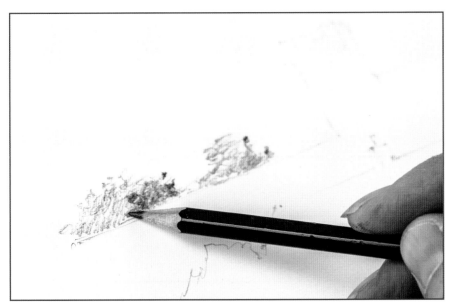

3 Pull some shapes forward by working on and around the two main horizontals, building the tone of the trees with hatching. Note that these have no edges beyond those suggested by the hatching itself.

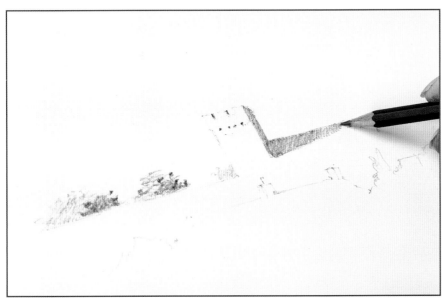

4 Avoid identifying objects if you can; just look for shapes, edges and tones. For example, the shadow cast by the tower onto the church roof is just a roughly L-shaped, hard-edged area of stronger tone than its surroundings.

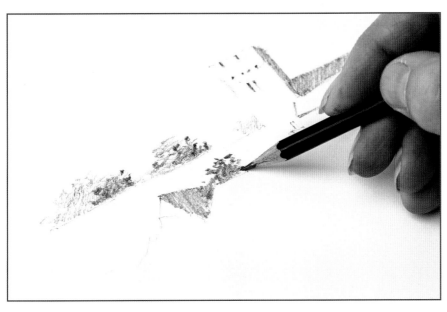

5 Continue with a travelling dark (see page 50) where possible and draw additional shapes as you need them.

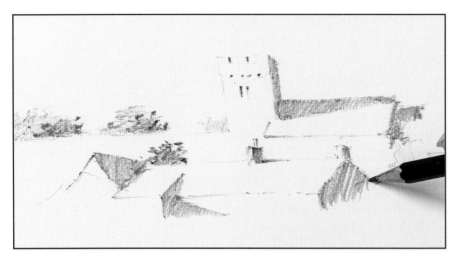

6 Take the picture piece-by-piece, building it up gradually as you refer to the other shapes, edges and tones on the paper.

Tip
Don't make the pursuit of perfect accuracy your goal at the expense of enjoyment and speed. If the shapes, edges and tones are approximately right and believable, the sketch as a whole will work.

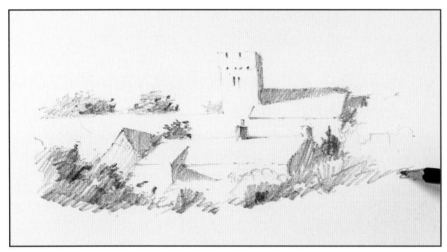

7 Resist getting bogged down in detail. With the main shapes (the rooflines) established, switch over to the foreground. Again, look for the correct shapes, quality of edge and depth of tone.

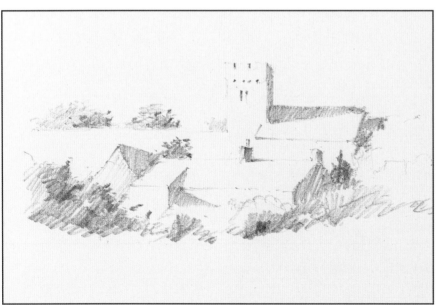

8 The basic sketch is effectively complete at this stage. The big shapes and high contrast areas are in place. We now need to make the smaller shapes read. Take a little break and look at the sketch as a whole before continuing. Which areas are you satisified with, and where would you like to spend more time?

9 Tease in some light midtones and develop smaller details with a close and firm grip on the pencil. Hint at roof tiles on the large sunlit roof to help give a sense of texture. Don't, however, get bogged down in drawing every single one. This is a sketch. You need to hint at texture, not painstakingly draw it out in full.

10 Continue to develop the sketch until you are satisfied. Be careful not to over-work it.

The finished sketch

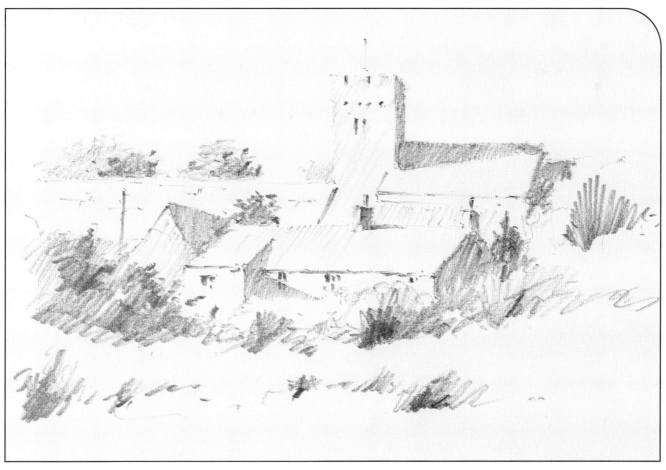

Types of sketch

In the previous chapter we discussed a range of techniques and different ways to approach making a sketch, but the type of sketch that you want to produce should also be considered. Indeed, this is fundamental: before you do anything, work out what you want to get from your sketch. Are you sketching purely for pleasure, or do you want to use your sketch to help you produce a separate painting? Perhaps you want to display your sketch, as a finished artwork in its own right.

What do you want to produce?

Not every sketch we make will be for the same purpose. Recognizing the reason behind the sketch will help us to focus on what's essential and what is not. I tend to produce three types of sketch: studies, sketches for composition, and sketches for atmosphere.

 The following pages give you some examples of each of these types of sketch, all made on a trip to Amsterdam in the Netherlands.

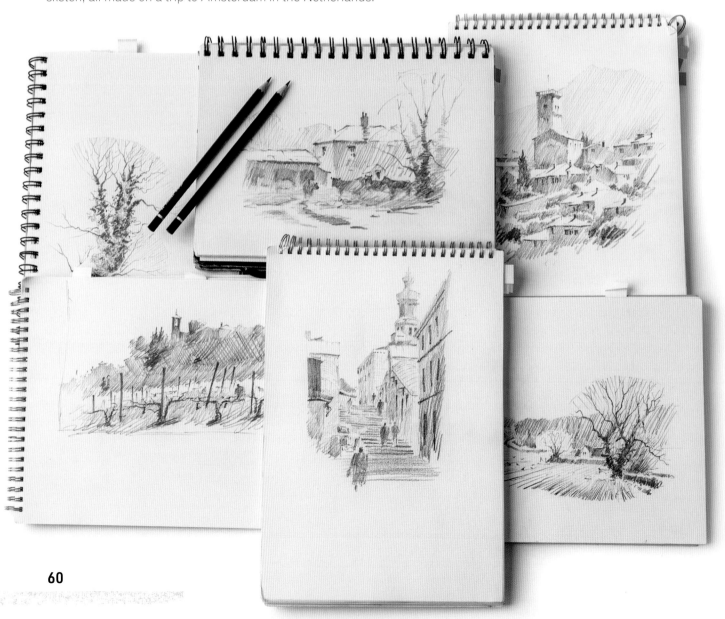

Studies

If you wish to include various objects in your compositions, then it would follow that you have to be able to draw these objects. And as the title suggests, the study is the way to do this.

A study is not about making pictures, it is an act of inquiry into how an object is pictorially constructed. The same rules of shape, edge and tone come into play, but now you must apply them to the given object.

You will start to notice certain characteristics: cows are much more box-like in shape than sheep, chickens are fundamentally sets of triangles, and the average car is at least two and a half windscreens high to its roof. Aim to be more concerned with proportions rather than detail in a study.

Remember that the more studies you do, the easier the future road will be. In my more considered sketches, I am now free to place people, cars and trees wherever and however I choose, because I have studied them scores of times. A good way to test if you know an object well enough is to try and draw it without a reference. Only if you have really studied the object in question will the result be convincing.

The more studies we complete, the more adept we become, until in the end we are able to draw a convincing shape with no reference as we have committed the 'feel' of the thing to our memory.

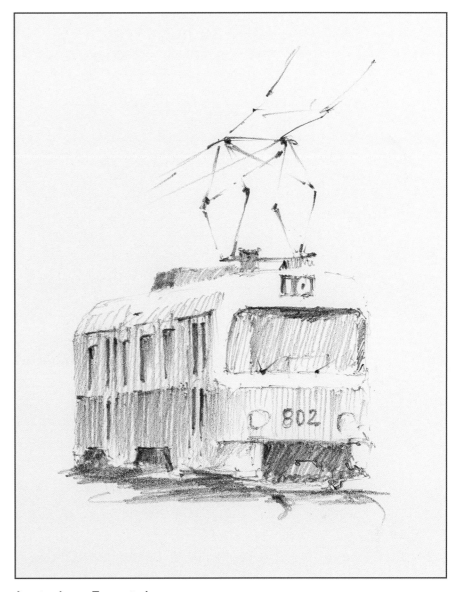

Amsterdam – Tram study

Here, only the tram itself has been closely observed, but it was important to include its relationship to the wires and road surface. These elements are essential if we are to attach it convincingly to its environment.

Compositional sketch

A compositional sketch deals with the placement and relationship of shapes, tones and edges within the picture plane. Put in a simpler manner, this means it is the pattern of shapes that is important. I will often sketch a scene because of its 'pattern' (composition).

Take a scene with rows of houses stacked steeply up a hillside. The experienced artist would not worry overtly about the number of windows or even the colour of the houses. The key thing would be the pattern of the interlocking rooflines because that's where the true power of the composition lies. Once we build up

our knowledge of composition we can start to move (or remove) objects or place them in more interesting postures. There are many books on composition available but the true key to a composition that pleases you is to learn why you like the scene before you. What is it that is appealing to you? Once you achieve this you can learn to push the bits you like and subdue the bits you dislike.

We deal with the different facets of composition on pages 84–97, and this form of sketch may help you in your quest to 'feel' your way to a good composition – building it from a 'bag of bits'.

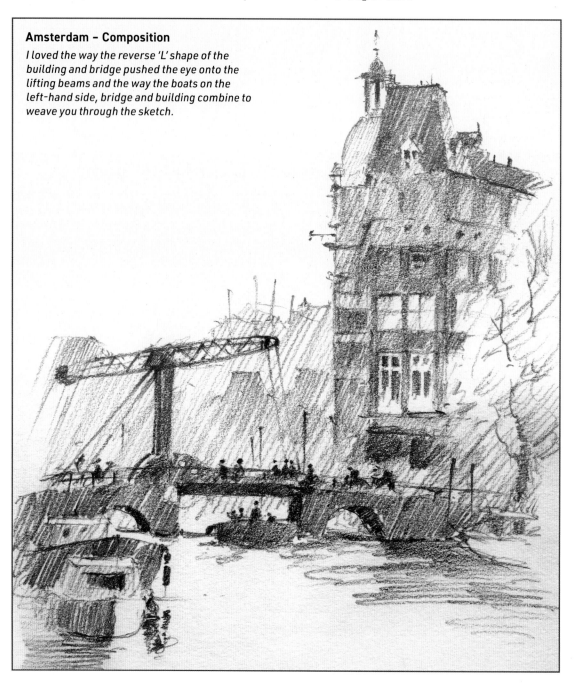

Amsterdam – Composition
I loved the way the reverse 'L' shape of the building and bridge pushed the eye onto the lifting beams and the way the boats on the left-hand side, bridge and building combine to weave you through the sketch.

Atmospheric sketch

As the title suggests, this type of sketch is primarily concerned with the atmosphere of the scene, rather than the structure or detail. The sketch needs to say if the scene is sunny, misty, bustling and busy, or quiet and calm. For the landscape artist, armed with either a brush or a pencil, atmosphere is the most dificult element to sketch or paint, and this form of sketching is invaluable if you want to move on to painting a scene.

Once again, astute and acute observation of shapes, edges and tones is essential to this sort of sketch. These will vary for each atmosphere or mood that we wish to portray. The same scene on a sunny day or a misty rainy day will have very different relationships in S.E.T. Similarly, comparing a busy, bustling scene with a quiet, calm scene will reveal a difference in the number of and size of the shapes.

When you are able to portray atmosphere in your sketches, then you can portray the magic ingredient: emotion.

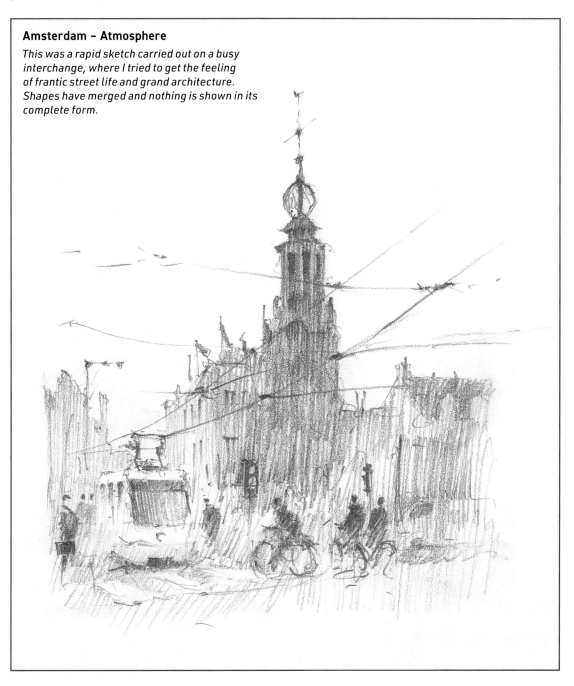

Amsterdam – Atmosphere
This was a rapid sketch carried out on a busy interchange, where I tried to get the feeling of frantic street life and grand architecture. Shapes have merged and nothing is shown in its complete form.

Beyond the pencil

Once we have sufficiently mastered the basic philosophy and techniques behind the successful use of the sketchbook, it is no major step to vary the materials and surfaces that we choose to work on. Indeed new drawing media should be as necessary 'grist for the mill' as new subjects to sketch. Whether trying out new tools or new subjects, it is important to remember that the key to confidence is still concentrating upon the shapes, edges and tones before you.

Using other media

Throughout this book we have dealt with the mind and methods of sketching, with the humble pencil as our tool of choice – and a fine tool it is too. It would be true to say, though, that any tool capable of making a mark on a given surface could be used for sketching: white chalk on a blackboard, a nail on a piece of slate, or even a soldering iron on a piece of wood. Indeed, any combination of tool and surface that enables you to produce shapes, edges and tones will allow you to sketch.

The media chosen by a given artist will depend both on that artist's personal preferences and the practicality of a given medium in relation to conditions of use and desired outcomes. For example, a piece of chalk and a blackboard is ideal for demonstrating the principles of sketching to a large group indoors, but would be pretty useless to take on a walking holiday.

The vast bulk of my own sketching is carried out with a pencil, but I often use a pen and sometimes I will combine this with washes of watercolour, for what is called 'pen and wash'. The other medium that I occasionally use is charcoal.

In this chapter we shall talk a little bit about my reasons for using the above materials and the way that I use them. We will also discuss the pros and cons of each as I see it in relation to my personal approach. It is not a full and detailed study of each medium, but more an explanation of them, and an introduction to them, from my personal application of each to studio and outdoor sketching.

PEN

Using a pen differs from pencil sketching in that a pen is more direct and will not erase or blend. There are a vast and varied number of pens available to the artist. The choice will ultimately be a personal one but it will inevitably depend on certain factors such as:

- The ability to render detail, where a fine nib may be required.

- The size of the sketch. If it is large, then a brush pen or liquid ink may be better suited.

- If it is to be a base for a pen and wash, then it will need to contain permanent and not watersoluble ink.

- If the sketch is to be produced outdoors, dip pens and matchstick and ink will be less practical.

The pen that I use most is the Kuretake Zig artist's sketching pen. It contains alcohol-based permanent ink that will take a watercolour wash instantly and has a nib that is capable of both fine and rich thick lines.

Other pens that you might like to experiment with include:

Fine liners I suppose that these are the most widely used pens for sketching. Again, quality varies and it is hard to find a truly waterproof ink. They come in a variety of nib sizes, measured in millimetres. Thinner nibs make a very scratchy line and hatching takes an age. I prefer a relatively broad 0.8 nib, as this makes hatching easy and a lighter, thinner mark can still be made by using the pen at an angle to the paper (see opposite).

Ballpoint pens The ballpoint pen comes in many guises and colours. A good quality ballpoint is a nice tool. The marks available though are somewhat limited compared with other pens.

Dip pens These are quill-type nibs, usually of brass, but sometimes bamboo. The nibs come in all shapes and sizes and a separate pot of ink is required in which to dip the nib. A single nib, pot of ink and a sketchbook are usable for our purposes, but a full set is too cumbersome for our simple needs.

Felt tip pens I know some artists who use felt tip pens for sketching but I find them crude and unsubtle. They also come in colours of course but these are too harsh for my tastes. It is only a personal opinion though, so if you think it may be your thing, then have a go.

Brush pens Similar to felt-tip pens, but with a flexible, brushlike nib, these are useful for larger, broader statements, though I rarely use them myself. On a small scale it is hard to achieve subtlety and easy to end up with a solid black mass.

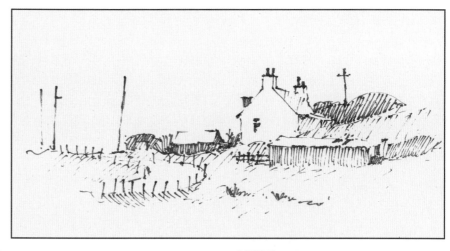

A Hill Farm
I love little pen sketches such as this. A pen works so well when there is a clear 'map' of lights and darks.

Pros and cons of using a pen

- *Big contrasts in tone are easier to render, as a pen makes a strong black dark.*

- *Colour can be used, which is very useful on occasion.*

- *It is possible to produce a more finished piece of work.*

- *Pen and wash – that is, painting watercolour over a pen sketch – is easier to handle than a full watercolour on a hot day.*

- *Pen is more permanent than unfixed pencil.*

- *Subtle tonal changes are harder to achieve and ink cannot be blended.*

- *No broad marks are available from a pen nib and hatching large areas takes time.*

- *More equipment is required.*

- *There is less room for error with a pen.*

- *Mist and soft-edged effects are harder to create*

- *The need to wait for washes to dry increases sketching time.*

How to hold a pen

Students fear a pen due to its perceived bold, intense line, but if it is used correctly, a pen is capable of surprising subtlety.

Broadly speaking, pens can be held in the same way as a pencil (see page 23): long and loose for initial marks and bigger shapes, closer to the nib for detail and more controlled marks. However, the way we achieve tone with a pen is very different – with a pencil we vary the pressure or 'weight' that we apply. The more weight, the darker the mark. With a pen this is achieved not by the pressure we place on the pen, but by its angle to the paper and its speed of use.

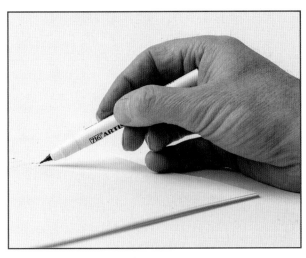

Shallow angle, high speed

Rapid light marks, achieved with the pen well over on its side, will result in light, broken sketchy marks. Their nature means that any errors will be barely noticeable in the finished sketch.

Mid-angle

Holding the pen more upright allows for bolder marks. Because the pen can be moved rapidly and comfortably across the paper, the marks can remain loose and free.

Upright and slow

Holding the pen virtually upright and moving it in a slow, considered manner ensures the nib has full contact with the paper surface. The results are darker, bolder marks; perfect for tone and accents.

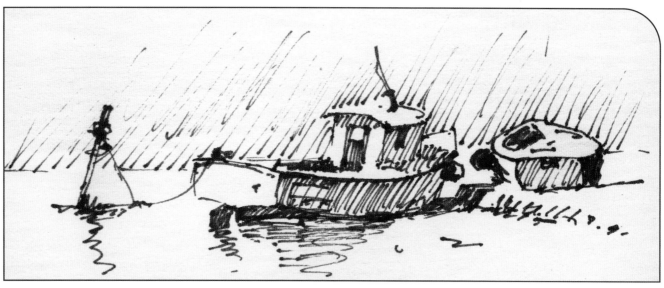

Study of boats

This little boat study, using a sepia pen, shows the variety of marks available when all of the ways of holding a pen (see the previous page) are used. From white paper to darkest darks and fine lines to strong lines, it's all there, and it was a joy to sketch.

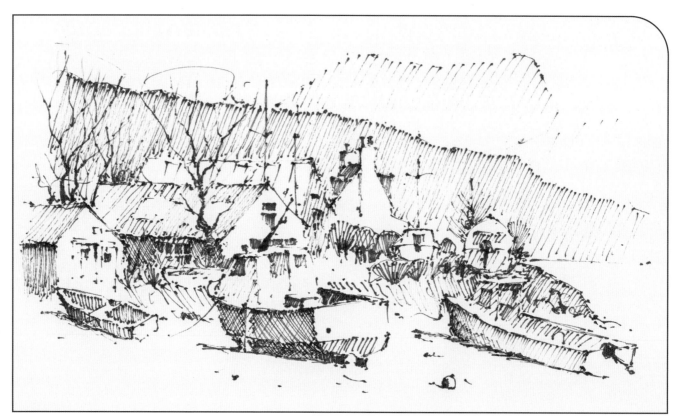

Portree

This studio effort with a sepia-coloured Zig pen has almost become a drawing. There is a lot of penwork here but no outlines are visible. The pen has been used at an angle for the lighter elements and fully upright for the darkest darks. A lot of crosshatching was used to achieve various degrees of tone, as on the side of the middle boat.

Sketching with a pen

Here is a little pen sketch that shows the different types of marks and shades of tone that we can make just with one pen.

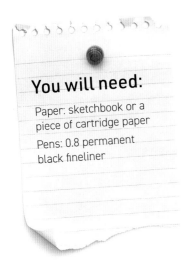

You will need:

Paper: sketchbook or a piece of cartridge paper

Pens: 0.8 permanent black fineliner

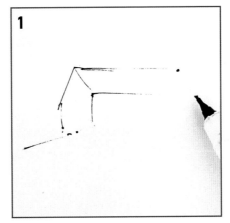

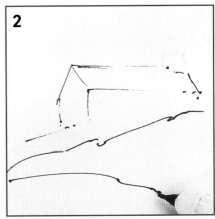

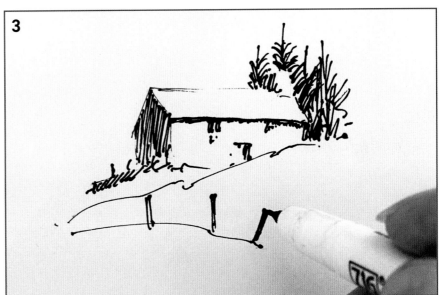

1 Hold the pen at a shallow angle and place rapid lines to start the sketch with the focal building.

2 With the building in place, swap to a mid-angle and sketch in some lines to indicate the surrounding ground. The different quality of the building and ground lines helps to show these are different materials.

3 For the darker marks, hold the pen nearly vertical to deliver rich, thick ink, full of contrast. For darker hatching, as under the roof, simply travel more slowly, holding the pen upright. For lighter hatching, such as in the fence to the left of the house, hold the pen at more of a slope and make faster marks.

WATERCOLOUR PAINT

When a sketch is produced, its important for it to 'say' something. Whether the key is a particular arrangement of shapes, a strong tonal contrast or the soft atmosphere, colour may also play a part. Sometimes it will be the very thing that attracted your eye.

I often complete full paintings on site, but it is not always conducive to do so. In such cases I will use my watercolours over either a pen or pencil sketch. The role of the pen/pencil is to provide shapes and especially tone. Because watercolour is transparent the sketch shows through the layers of paint, giving me shape, edge, tone and colour in the finished sketch.

If I want really strong sunlight then I err to a pen because of its ability to produce strong darks (such darks with a pencil are possible, but the graphite makes the wash slip off, in the same way as wax). A pencil is better for softer scenes such as rain, but I will often use whichever I have in my particular sketching kit.

Pen and wash is much easier (and quicker) than actual painting, and thus much less intimidating.

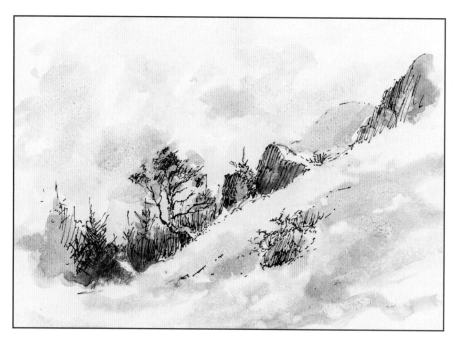

Glen Coe

Here the watercolour wash went on in one go, from top to bottom. The speckled effect that can be seen in the wash is midge spray. My partner had to keep spraying me – quite literally – as I appear to be top cuisine for any biting insect.

What you need

Besides a pen with waterproof ink, you don't need a huge amount of additional material. It's a sketch, remember, so you don't need forty-eight colours and an array of brushes, just a small set and a couple of brushes – like that shown to the right – is sufficient. There is specific information on the brushes and paints I use on page 12, if you would like a simple list. More important than a vast array of colours is portability and self-containment. Notice how the little box I use contains a small water carrier and water holder.

Similarly, there's no need to buy a dedicated sketchbook. An ordinary sketchbook with a reasonable weight of paper, such as 240gsm (90lb), will be fine for pen and wash. I have used lighter paper which buckles a bit more, but as it's only a sketch, this does not matter. On occasion I have also used a smoother watercolour pad.

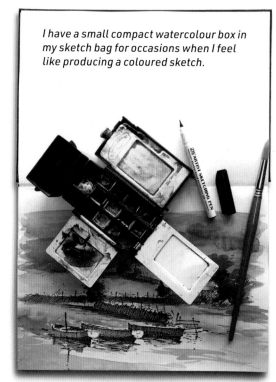

I have a small compact watercolour box in my sketch bag for occasions when I feel like producing a coloured sketch.

Painting basics

Pen and wash can be used in different ways, but for this artist, the pen is used first, to produce a tonal sketch. The watercolour is then used to provide information on colour and to add additional tone over larger areas if required.

If you have never used watercolours before, don't be intimidated. You need to know how to prepare your paints, which is shown below; and a small exercise follows overleaf to show how to use watercolour to enhance your pen sketches. I use pan watercolours, which are hard blocks. These need wetting before use: simply dip your brush into clean water and drop a drip or two on each pan as you need it (see right).

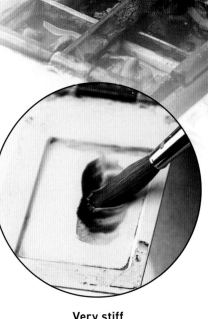

Watery

This consistency is very fluid. Prepare it by adding clean water to a well in your palette, then use your brush to lift wet paint over into the well. The mix should form drips from your brush.

Stiff

Still fluid, but surface tension will loosely hold this consistency of paint in place. Different colours will interact as shown, but not readily merge. Start from a watery consistency and add more paint to the well.

Very stiff

Paint prepared to this consistency will stay just where you place it, making it good for later details. To prepare it, simply use a damp brush to pick up paint from the wetted well: there's no need to add further water.

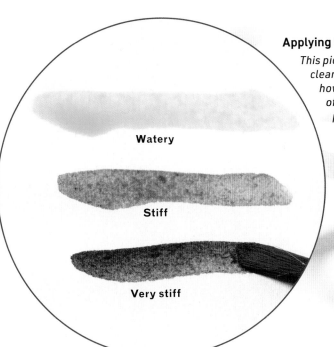

Watery

Stiff

Very stiff

Applying the paint

This picture shows how the three consistencies appear on clean white watercolour paper held at a slight angle. Note how the watery consistency is starting to form a 'bead' of paint at the bottom, while the other two remain in place. The very stiff consistency mark has crisper edges than the other two.

Painting over pen

Let's look at how easy it is to add watercolour to a pen sketch. This painting technique is ideal for sketching as it's such a quick way to record colour on the spot.

It's also a great demonstration of how different consistencies of paint (see page 71) work together, so even if you have never painted before, it's worth a go.

You will need:

Paper: Not surface watercolour paper

Pens: 0.8 permanent black fineliner

Watercolour paints: cerulean blue, lemon yellow, French ultramarine, burnt sienna

Brushes: size 10 round

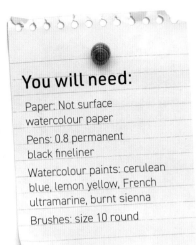

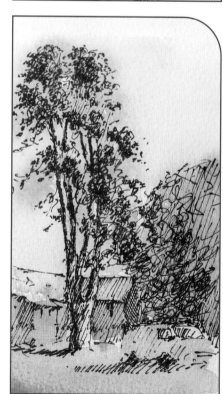

1 Create the sketch using permanent ink, and ensure it is dry. With a size 10 round brush, use clean water to wet the surface all over the sky and trees.

2 Add watery cerulean blue to the sky area while the surface remains wet; a technique called wet-in-wet. Work right over the outer branches of the trees, but avoid the inner part.

3 Add lemon yellow to the cerulean blue on the palette, making the mix stiffer. While the paint remains wet, paint the resulting green mix over the foliage. Try not to treat them as individual trees, but rather as an intermingled mass.

4 Vary the hue of the foliage by adding a stiff mix of French ultramarine and burnt sienna on the right-hand side. Once you have largely covered the foliage, allow the painting to dry.

5 Continue building up the painting with stiffer mixes. Watercolour at this consistency will only flow where the surface is wet, so it gives you control, allowing you to work 'wet on dry' at your leisure.

The finished sketch

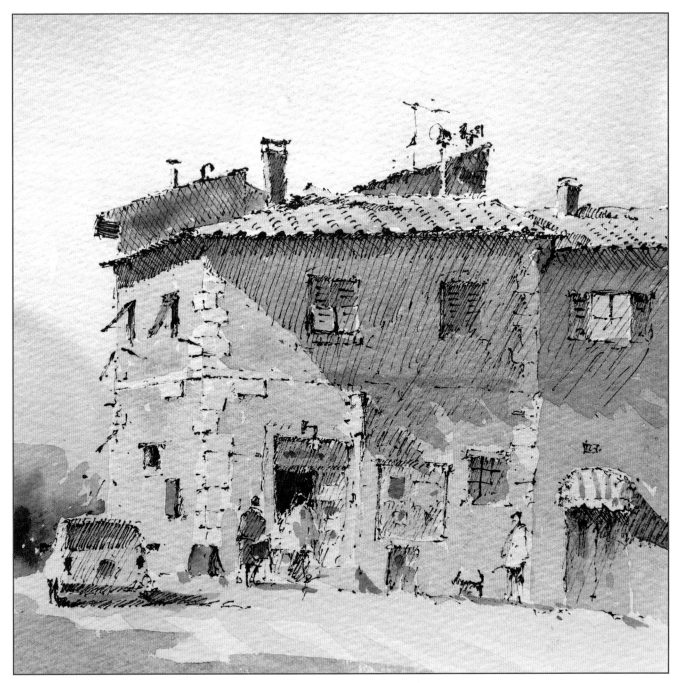

Volterra Corner

The pen I had to hand for this sketch was a very skinny 0.2 nib – I tend to use at least a 0.7. As a result I was there for what felt like days and days trying to get a decent weight of hatch into the dark areas. The locals thought that I was singing, but I was just swearing in Welsh.

The wash went on in separate blocks because I thought it important to keep the white cornerstones and other bits of white paper too. I think this helped with the impression of sparkling sunlight.

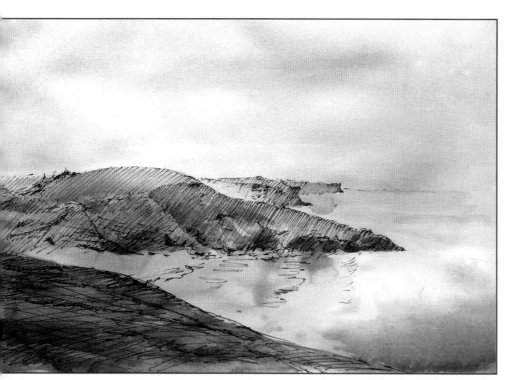

Southerndown

While it is very suitable for architectural subjects, a pen can also be used for open landscapes. It would have been easy to fall into the trap of rendering every crack, crevice and tussock, but as I use a pen predominantly to render tone, I was able to work broadly to chase the atmosphere and not the detail. Notice how the watercolour wash has caused the 240gsm (90lb) paper to cockle.

Ghent

Wandering around the older quarters of some European cities with a simple pen and wash sketching kit is a beautiful way to really look at a city.

To my mind the pen should sit nicely within the washes and should not dominate. I try and achieve this by placing fairly rich watercolour washes over the pen to 'knock it back' – that is, to soften the contrast and prevent it from appearing too stark.

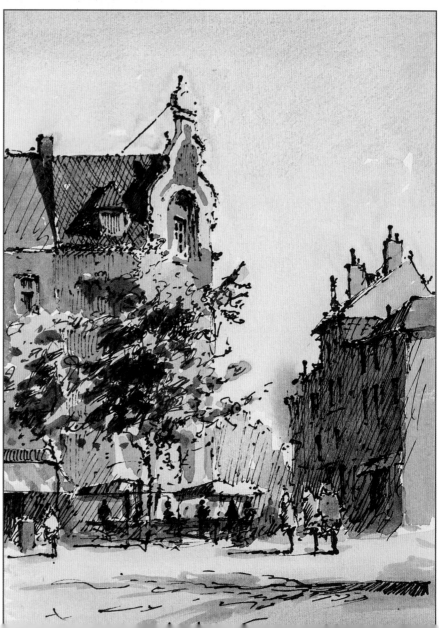

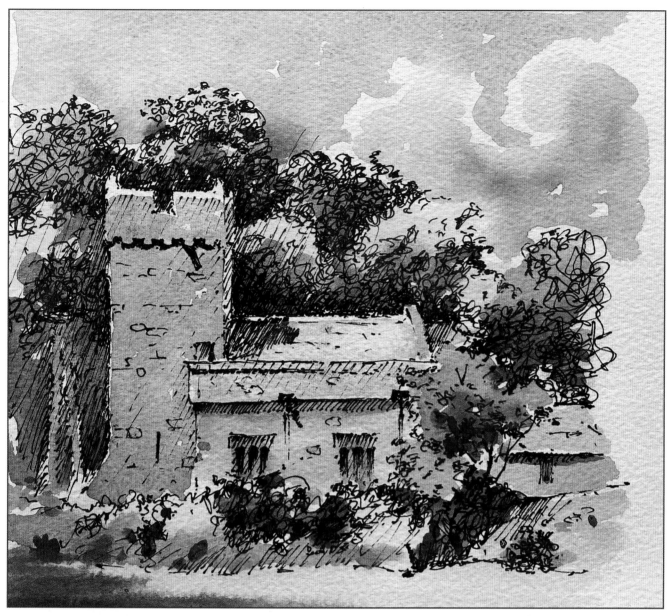

Church at St Donat's

This is quite an elaborate pen and wash sketch of a local church. It illustrates the advantages of different media well: the dark trees demanded a lot of pen and it would probably have been better for them in particular if I had used a pencil, but then the light effect would not have been so good. It has been sketched on a pad of Bockingford rough surface watercolour paper, hence the lovely texture.

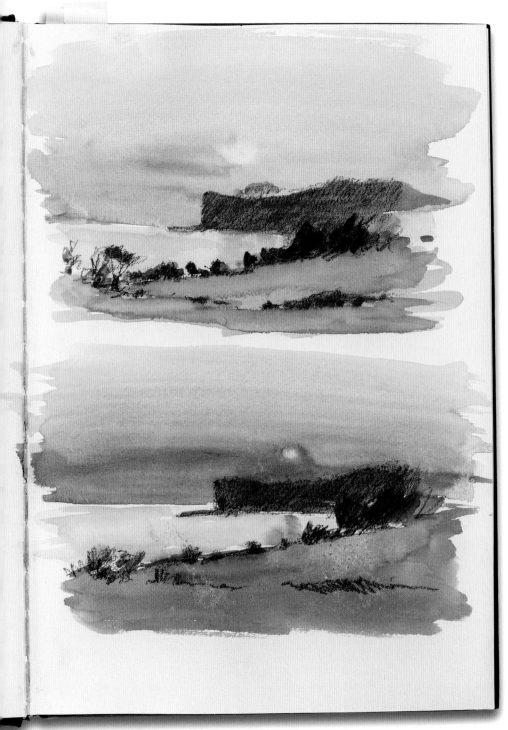

Pencil and wash

The pencil and wash technique is all but identical to pen and wash. If you are a novice, however, pencil and wash can be less intimidating, due to the fact that pencil marks can be removed or adjusted prior to you applying the paint. Conversely, once you are finished, your pencil sketch will not smudge, as the watercolour has the effect of 'fixing' the pencil.

As pencil and wash works are really just a pencil sketch with watercolour added, your usual 2B or 3B pencil will be fine to use, as will your usual sketchbook.

A pencil gives a much softer sketch than that produced with a pen, so as mentioned previously it is better at capturing rainy and cloudy days than bright Mediterranean sun. However, as I tend to have pencils with me more often than pens, I will use them for sunny scenes as well.

Sunset, Col-huw

Sunsets are very fleeting moments, as can be seen by the colour difference between these two sketches carried out one after another on a summer evening from the clifftops near my home. The pencil work took mere seconds and then on went the washes. As the top one dried, I sketched the second.

Storm Sun

This is a sketch that had to have colour as it is an integral part of the 'message' that the sketch wishes to portray.

Minimal pencil work was used in the mid ground for the farm, and in went the colours. I managed to find a pen and while it was drying I added some pen to the farm for yet more tonal impact. The foreground shadow was placed after the first wash was just about dry.

Milford Sound, New Zealand

What a beautiful place, utterly spoiled by mass tourism. The noise level from helicopters, boats and crowds ruin this otherwise awesome location. The sky and land received the first wash and when this was dry, I added further washes for the mountains. It was sketched and painted standing up, which is achievable if you have the right set-up.

In this case the right set-up consisted of me standing with the sketchbook resting on my left forearm, held in place with my fingers and with my small self-contained palette hooked onto the thumb. This left my right hand free to wield first the pencil and then the brush.

The whole procedure is much easier when sitting down, of course, because the sketchbook can be placed on your lap and, if the seat is low enough, the paints can be placed on the ground.

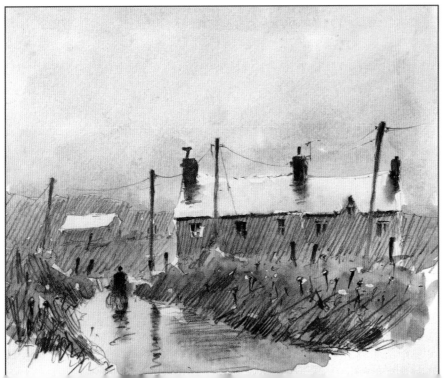

A Wet Ride Home

The lovely hedgerows and sky here demanded to be sketched. The van was parked on the sodden verge – but only after I had climbed out to inspect its soundness.

To my mind, the close tones of this scene suited pencil and wash rather than pen and wash, which I tend to use for brighter, stronger-toned subjects. I could also have rendered it in pencil only, but the wash really pulled out the colours in the hedgerow.

MATCHSTICK AND DIPPING INK

Occasionally, if I feel like loosening up my sketching I will use a sharpened matchstick and dipping ink as here. It is actually quite a flexible process if you put the dark marks in when the matchstick is loaded with ink and the broken marks as it starts to run out.

I quite enjoy the looseness of the marks produced with this technique, and it is good for simple sketches of strongly lit subjects. The technique is versatile: if the ink is waterproof, then it can also be used with watercolour washes.

You can also substitute the matchstick for a nearby twig.

You will need:

Paper: sketchbook or a piece of cartridge paper

Other: matchstick, craft knife, permanent black ink

The scribbles you can see at the top of the page in this sketch are where I have tested the mark of the matchstick before the sketch.

1 Use a utility or Stanley knife to trim the matchstick to a point. Always cut away from yourself, as shown.

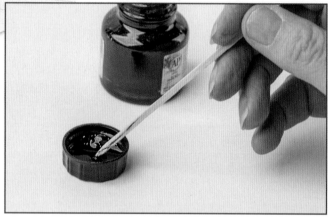

2 Pour a little ink into the lid (you can use a separate receptacle if you prefer), and dip the pointed end of the matchstick in to load it. This helps to ensure you don't overload the stick, which will result in a lack of control.

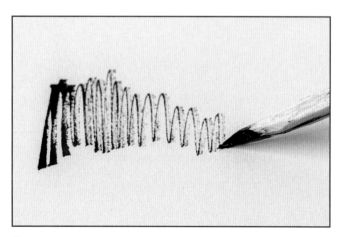

3 Test the marks you can make with the stick before starting to sketch. This will help you to understand how to handle the individual matchstick for best results.

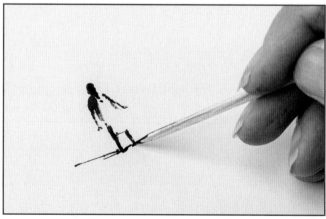

4 You can now sketch as though using a pen. The results usually have a pleasing scratchiness and texture.

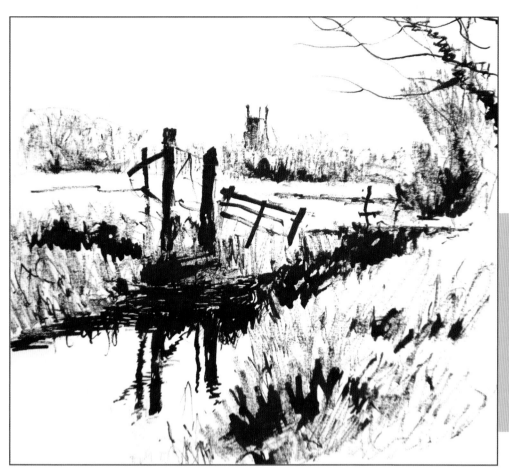

Ditch near Glastonbury

There is a lot of dark ink work here, which makes for a very powerful composition.

The reflection in the ditch and the church in the distance made a lovely subject – once I had pulled the dog out of the ditch.

Loosen up

If students are being too fussy and over-detailed, I often introduce a matchstick and ink session, as an antidote to the compulsion toward unnecessary detail, which is impossible with these tools.

They remain versatile. As long as the ink is permanent, you can use pen and wash techniques with them.

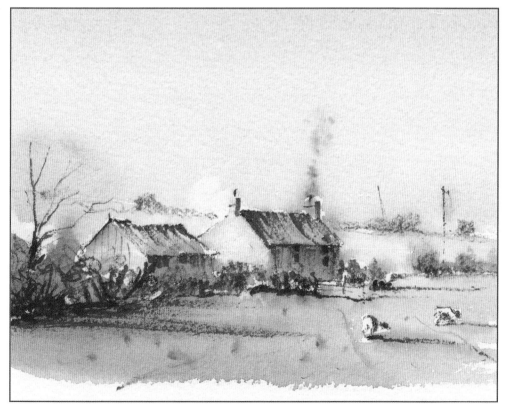

Hill Farm

The ink works well on watercolour paper and as is evident here, lends itself to simple, direct marks.

CHARCOAL

Charcoal for drawing is usually made from willow and is more commonly associated with portrait and life drawing than landscape sketching.

In the right hands, however, it can produce rapid sketches of surprising subtlety and atmosphere. I tend to use it in changeable, stormy weather; when speed rather than finesse is of the essence.

Blending stump

These are used to smudge and soften charcoal marks into the surface (see opposite).

Large stick

Being a natural material, charcoal varies in size and shape. A variety of sizes will give you options.

Pros and cons of using charcoal

- *Charcoal can be a very quick method of working when used broadly and with confidence.*
- *It is excellent for rendering softer atmospheres.*
- *Large pieces of charcoal make larger sketches easier and quicker.*
- *The use of a putty eraser means that you can work from dark back to light.*
- *In comparison with pencil, charcoal is a messy medium.*
- *It is less permanent than pencil.*
- *It is harder to use for small sketches due to its broader, softer nature.*
- *Detail is harder to render than with a pencil.*

Fine stick

Charcoal can be used in long fine sticks (above) like a pencil or pen. Snap it into smaller lengths (below) for detail.

Next Door's Roof

It was a hazy day and the roof of the house next door was shining somewhat. The first step was to quickly cover the whole paper with a light layer of charcoal, while avoiding the roof of the house – a simple enough task, complicated only by the fact that I was trying not to fall out of the bedroom window from which I was sketching. The broad shapes of the trees and house sides were then stated, again with the side of the charcoal. Finally, using the edge of the charcoal to get a point, I drew the fine detail of the branches and so forth.

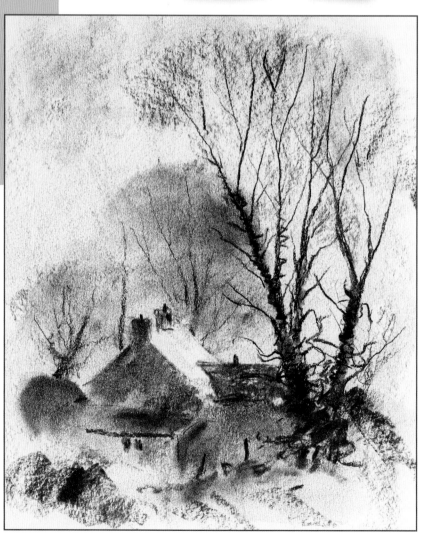

How to hold charcoal

Unlike pencils and pens, any part of the charcoal can be used to make a mark.

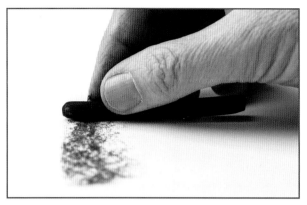

Side of large stick

You can see now why I refer to this way of holding a pencil as the 'charcoal grip' (see page 23). Holding the charcoal like this allows you to make broad, sweeping strokes that quickly cover an area. When using a new stick, natural curvature in the charcoal may mean that you can only get part of the stick in contact with the paper, as shown. Charcoal is very soft and will quickly wear down, so if you want to use the whole length, just rub it down on a scrap of spare paper until you achieve the mark you want.

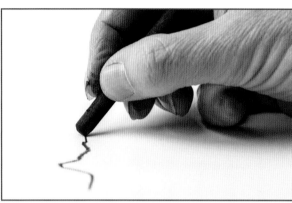

Tip of large stick

The ends of large sticks can be used just like a pencil or pen, to produce finer marks. You can use any of the pencil or pen grips detailed on page 23 and 67. Just be aware that charcoal is brittle: too much pressure on the tip can cause it to splinter.

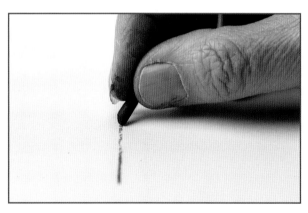

Tip of fine stick

For details and particularly fine marks, it is usually better to switch to a smaller, finer stick. This gives you more control than a large stick, and there is less risk of mess.

Blending charcoal

You can blend charcoal on any surface, but it is most effective on textured paper, like watercolour paper. Worked lightly, it will sit only on the raised 'tooth' of the paper.

You can smudge charcoal marks into the recesses of the surface with a blending stump (see right) or finger (see far right) to achieve a smooth, soft effect. A stump is useful for precision – and involves less mess, of course!

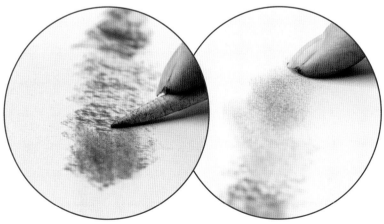

How to use charcoal

Charcoal is best used broadly: a bold 'big shape first' approach will give you the best results. It is, however, also capable of both subtlety and detail, and this small exercise aims to show this.

You can use any surface for this exercise, but I recommend Not surface watercolour paper (see page 14), as the texture allows you to make the most of this versatile medium.

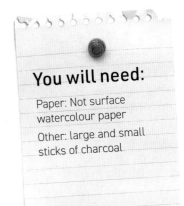

You will need:

Paper: Not surface watercolour paper

Other: large and small sticks of charcoal

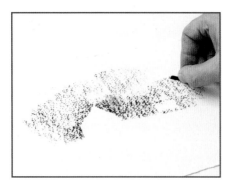

1 Use the side of a small piece of charcoal to block in the basic shapes, leaving space for the main buildings.

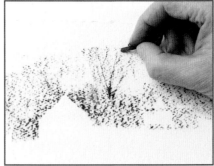

2 Use the tip of the charcoal to suggest the main branches of the background trees.

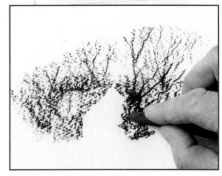

3 Use both the side and tip of a large piece to strengthen the tone, building up the tree trunk and shadow to the side of the building.

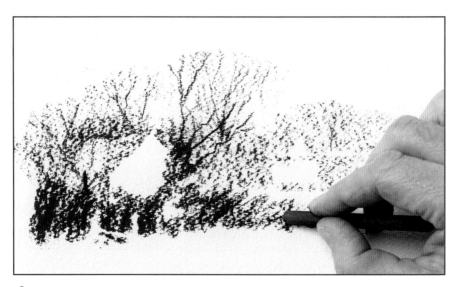

4 Block in the foreground with the side. You can adjust the angle at which you hold the stick to make larger or finer strokes.

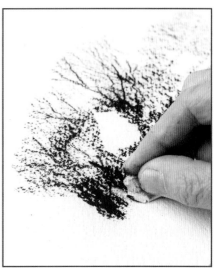

5 Use a putty eraser to lift out the shapes of the fence in the foreground.

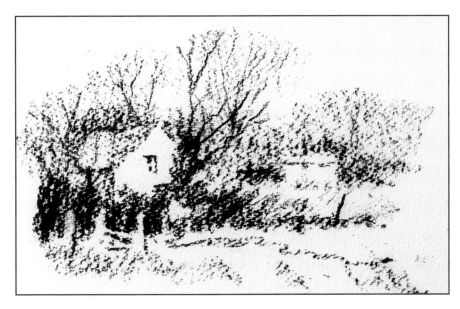

6 Pick out details with the tip of a small piece of charcoal to finish.

Barn in the Black Mountains

Charcoal is superb for rendering atmosphere. When used in a broad sweeping manner, as here, it feels more like a painting medium than sketching.

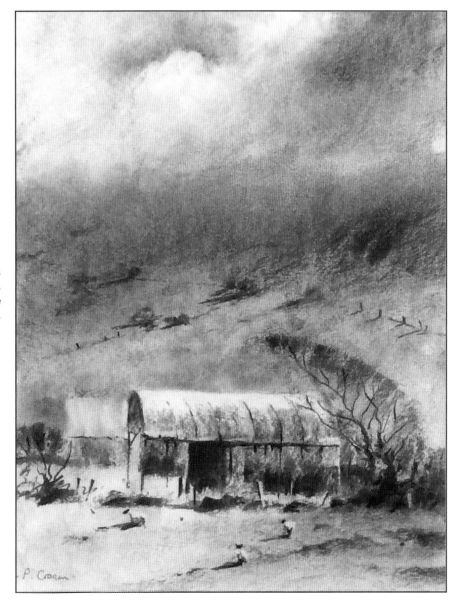

Composition

Composition relates to the way that you choose to put shapes, edges, and tones together. A poor composition will result in a nondescript sketch that fails to tell a story; that lacks a focal point; or is simply empty of that 'wow' factor that is so attractive in a well-executed sketch.

An effective composition will lead the eye to a focal point, make it linger and then allow it to leave the picture plane. It is not an easy thing to do, but it does get more intuitive as one gains experience.

Presented on the following pages are some factors that help to produce stronger compositions. They will have a subconscious effect on the viewer who will not understand how they have been seduced; but we are artists and must understand the science behind the seduction.

With this in mind, I have pulled out some of the themes and thoughts that, for me, inform the broad topic of composition. They were not instantly available to me as a novice, but grew on my consciousness as I built my experience. Remember, the layperson may like a given scene 'because it's nice', but the artist knows why they like it, understands the components outlined here, and knows how to use them to depict and enhance the scene.

Glastonbury Morning Mist

We had a husky named Draco. He could cross his legs all night in the camper van, but by early morning he would be desperate to get out. We found this, one early morning, and what a sublime composition it made. I set to work, while Draco diligently inspected every one of the fenceposts you see in the sketch.

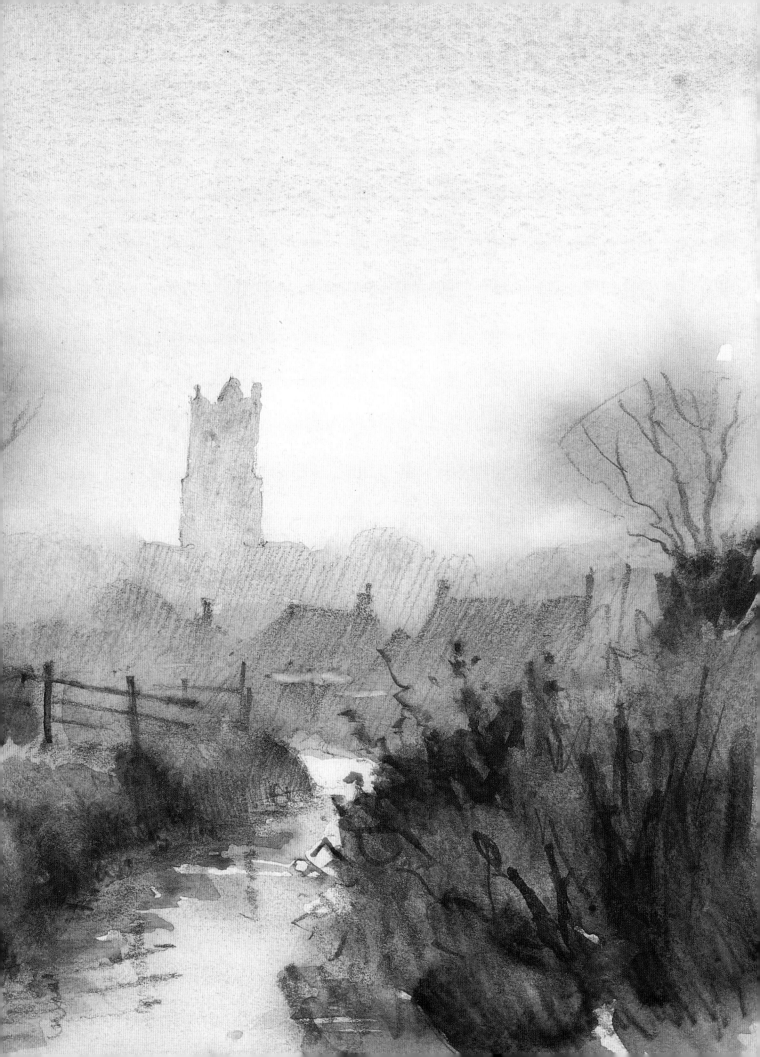

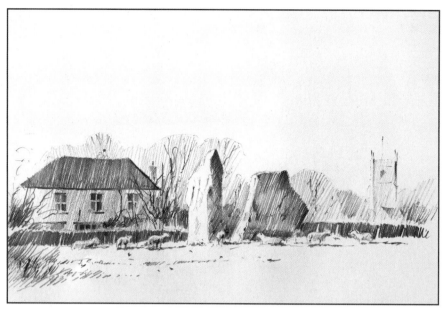

Focal point

This is where we wish the viewer's eye to rest. It is often the reason that we wish to sketch the scene in the first place: it's the star of the show. Sometimes the focal point will be obvious, but at other times it may be more subtle and harder to discern. On a sunny day we may wish to sketch the sunlight for example, but there will be a reason why we chose 'this' sunny scene over other possible compositions. Was it the light roof or the dark interior showing the lit tabletops? We need to find out or our sketch will lack purpose. All the other points listed here will help us in our quest to produce a sharp – or subtle – focal point.

Sheep and Stones, Avebury

There were so many potentially eye-grabbing shapes in this scene that it was important to handle it correctly. The title is 'Sheep and Stones' and while I think I have given the stones sufficent emphasis, I'm not so sure about the sheep.

Notice the white paper and darkest darks on the stones in an attempt to pull the eye, and how the subdued mass of the house helps keep the eye over to the left and away from the church, which is meant as a treat at the end of your gaze.

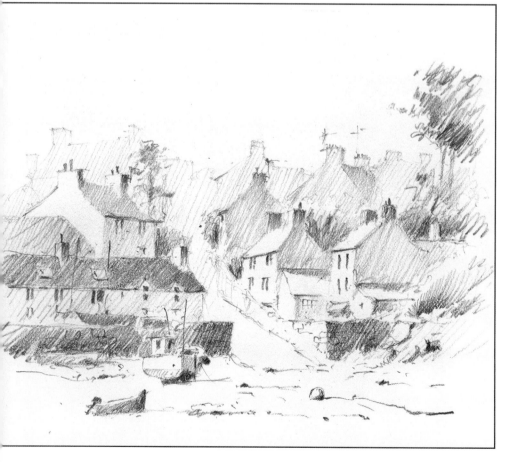

Rhythm

In a piece of music it's the rhythm that produces the 'feel' and 'tempo' of the piece. It's the same in picture-making too. To create rhythm we use repeated shapes, but we vary them. Think of roof tops bouncing up a hillside or old fenceposts twisting away into the distance. Understand, too, how repeated verticals set a different mood to repeated horizontals. Spotting rhythm in the views we choose will help our compositions to sing... pun intended!

Brittany Backwater

We were wandering around Brittany and looking for a place to park the campervan for the night. The sketch is rapid and rough but successfully represents my feelings about the place. It has a pattern and a rhythm that comes from the repetition with variation of a shape: in this case, the gable ends.

A larger picture of this sketch can be seen on page 39.

Connected shapes

Connected shapes can help to strengthen a composition by reducing busyness, increasing mood and acting as directional lines to guide the viewer. In nature, shapes tend to become more connected when they are distant; in shadow, mist, or rain; or directly in front of bright light. Remember, the novice is looking to find detail and edges, while the experienced artist is looking to lose detail and edges. Connecting shapes will help you to do just that.

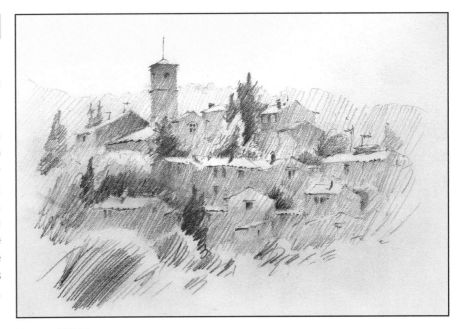

Tuscan Hill Town

This Tuscan hill town was sketched looking into the hazy morning light. This meant that apart from the light roofs and a few strong darks it could be drawn as one fused, connected shape. If the light had been in front of the subject, rather than behind, it would have held vastly more detail. For atmosphere, look to fuse, not separate shapes.

Weight

When we talk about weight we are usually referring to the way that shapes and tones are distributed over the paper. Too many shapes and too many heavy darks on one side of the composition can 'unbalance' the sketch, leaving the other side looking redundant and disconnected. I use the words 'can unbalance' and not 'will unbalance' because all rules can be broken if you have the knowledge. In a landscape, for example, we often want more weight in the land area than the sky. Generally speaking, having more or less weight here or there is fine, but a complete imbalance usually fails.

A Field Corner

In strict compositional terms, this sketch should not work, as the bulk of the weight is on the right-hand edge. It is saved by the darks in the foreground furrows that temporarily stop the eye, and the fenceposts that pull the eye leftward after the tree is viewed.

■ Accents

If I am away from home with a group of people, as soon as I speak, people will look at me. I have a very strong Welsh accent that is quite different from the rest of the UK. (At least I think that's what it is – I do try and shower quite often!) The accent plays the same role in picture-making: it's a strong dark or a strong light that stands out from what's around it.

 The three little doodles below show how, by using both light and dark accents, we can pull the viewer to certain parts of our sketch: the window, boat bow and figure respectively. Your white paper and darkest marks are the stars of the show and you should use them wisely.

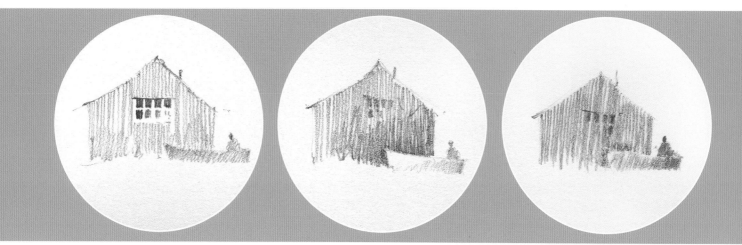

Accent on the window

Dark tones on the window draw the eye. Although the tones on the house and boat are both light in comparison with the window, note that they are still distinct from each other to help the areas 'read'. The boat and figure, however, are treated as a single shape here, to prevent them drawing the eye.

Accent on the boat bow

The points of highest contrast – where the lightest light is placed next to the darkest darks – will always draw the eye. Here, dark tone on the building provides a frame for the clean paper of the boat bow, creating the shape through negative drawing. The other end of the boat is toned in lightly to help it show against the white paper.

Accent on the figure

The dark figure is framed by clean white paper, and the other tones are all various midtones. Slightly different tones have been used for the boat and building, subtly helping to distinguish them from each other.

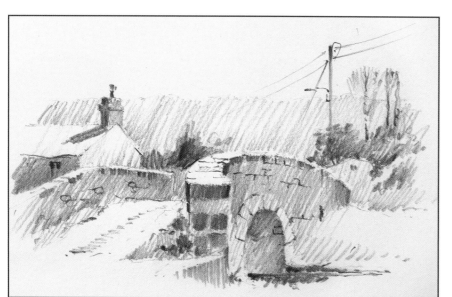

The Canal Bridge

I was sat on the step of the camper van drinking a cup of tea when the light on the parapet wall caught my eye. It makes an unusual and powerful composition, helped by the darks that I have placed around the lit area. As an aside, look at the directional hatching on the path and bank to help give simple form.

It also occurred to me that when you sketch, you end up drinking a lot of cold tea!

Simplification

The more complicated the subject, the more we need to simplify areas. We simplify by connecting shapes omitting and softening edges.

The simplification of this scene was essential and I have deliberately joined shapes, lost edges and fused the backdrop and foreground. Compare the sketch with the source photograph to see where I have cut out unnecessary detail.

Source photograph

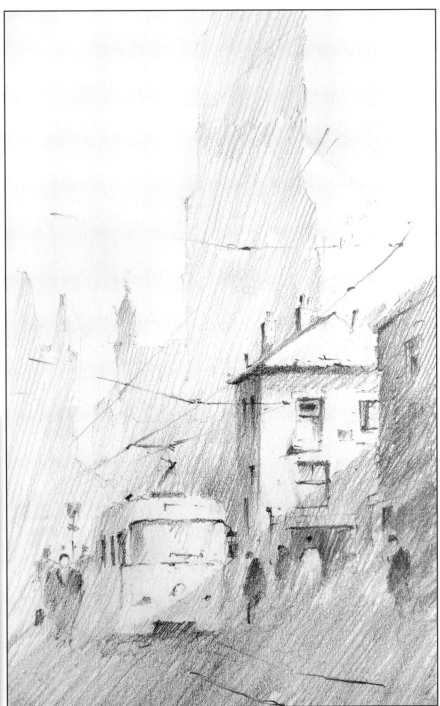

Ghent

A dramatic composition, due to the angular lighting and the church thrusting out of the picture plane. There is a lot of fusion here, but there is still more detail in the foreground than the background. The overall hatch is stronger at the front, too.

Creating a sense of distance

A sheet of paper is a two-dimensional surface, so we need to be able to suggest distance through how we draw what is in front of us. There are a number of ways to achieve this; here are the methods most often used:

Size Objects in the distance are obviously smaller than nearer objects of the same size, so nearer objects must be drawn larger.

Contrast Distant shapes will be closer-toned, with less extreme lights and darks than foreground shapes. Our outlines become softer and more broken the further away they are, and our hatching lines need to become lighter, and/or further apart.

Colour Owing to dust in the atmosphere, colours that are further away contain less hue than nearer colours, which will be far richer and stronger. Very distant shapes will often turn to shades of grey and blue. This effect is sometimes called aerial perspective.

Detail Detail is lost as the distance increases, so we require more fusion of shapes, tone and edges for distant objects than those nearby. Simplification is the key.

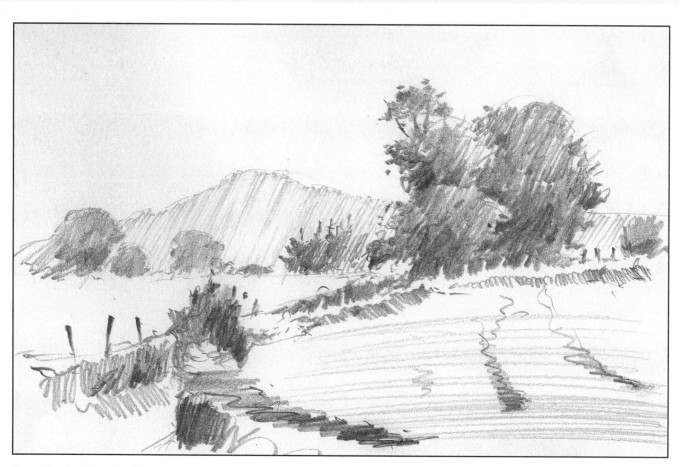

Towards the Sugarloaf

The distance in the sketch above is shown in all the ways that we have discussed. The distant mountain is faint and undetailed while the far trees are lighter and smaller. The strongest tones are reserved for the foreground.

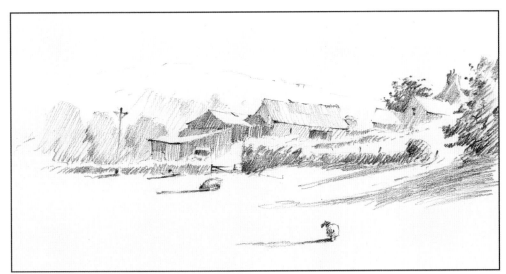

Farm in the Evening Sun

I loved the way that the farm and its associated buildings just trailed down the hill. It's a lovely example of 'repetition with variation' where shapes repeat in a slightly different manner. It's a compositional device that I – and many others – use all the time.

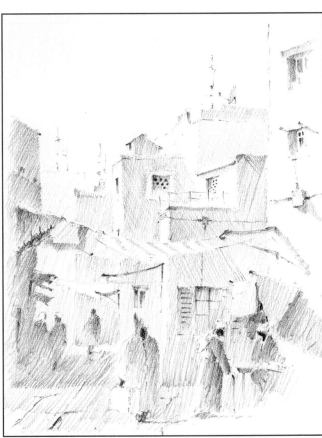

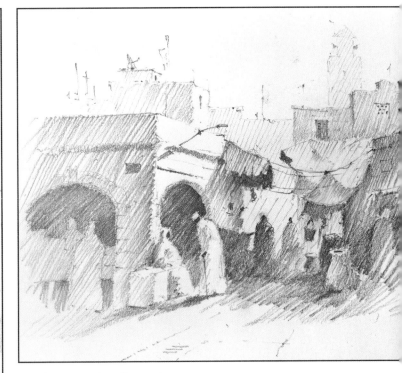

The Conversation, Essaouira

This proved to be quite a complex composition, sketched from my tablet while sitting around with friends in the evening. I grunted 'yes,' and 'oh?' occasionally, to show willing, but they knew that they'd lost me back into the day's events.

Morning Light, Marrakesh

Very subtle changes to the pressure I placed on the pencil were required to achieve the subtle aerial recession evident in the buildings in this sketch.

Fixing the Farm

This little group of farm buildings looks promising, but as it was not designed by an artist, it's too busy. I shall need to simplify areas, consider whether to crop the image and work out how to establish a focal point by adding accents to draw the eye. I have the use of all the 'tools' explained on the previous pages to make this a better composition.

Improving on a photograph: the plan

Start by asking yourself what appealed to you about the scene, so that you can retain that and remove the parts that work against it. What is the scene saying to you? Consequently, what's our title to be? Here, what light there is, is coming from the right-hand side. And cows… yes, cows.

The photograph below shows a few of my thoughts in planning. I shall be leaving loads of bits and pieces out and may even employ an engineering firm to move the silo. Let's see what happens.

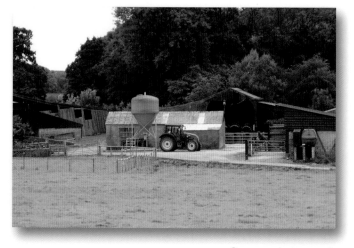

Source photograph

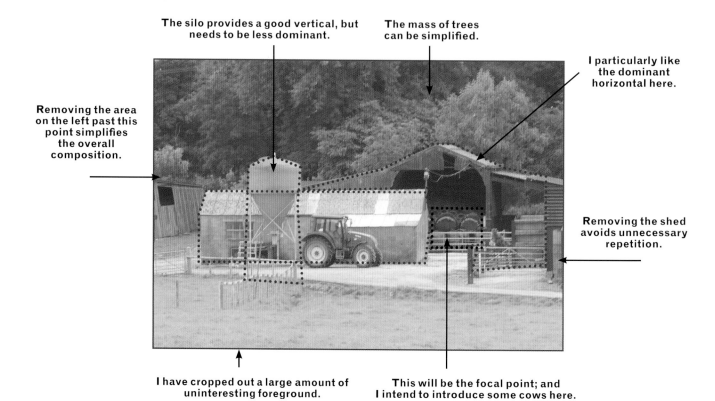

The silo provides a good vertical, but needs to be less dominant.

The mass of trees can be simplified.

I particularly like the dominant horizontal here.

Removing the area on the left past this point simplifies the overall composition.

Removing the shed avoids unnecessary repetition.

I have cropped out a large amount of uninteresting foreground.

This will be the focal point; and I intend to introduce some cows here.

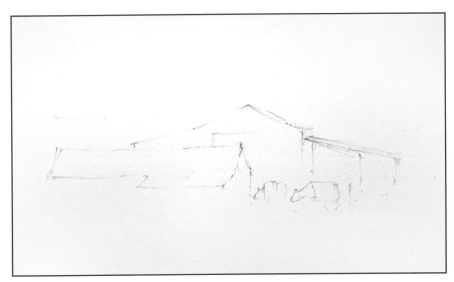

1 Use the 3B pencil to chase in some light lines. Don't worry if some are in the right place and some are wrong: just restate them without rubbing out the offending lines. Here we are interested in four main shapes: the two barns, the cows and the silo (yet to be placed), but the finished sketch must point to the cows and lit gable as the focal point.

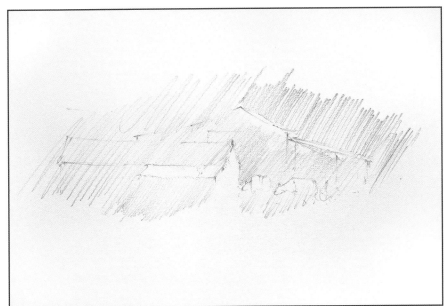

2 Go in with a loose light hatch to try to isolate the areas that are to remain as white paper. Use your finger as a guide (see page 44) to speed things up.

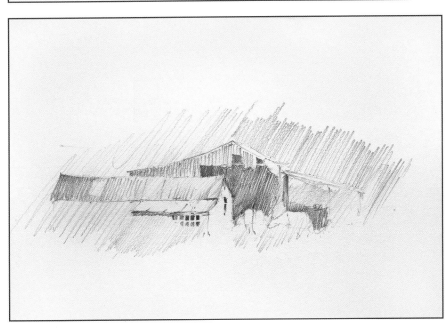

3 Hatch in the dark interior of the big shed to pull out the gable end and the cows (our focal point). Next, start adding a minimal amount of further tone and detail to the front barn using mostly directional marks.

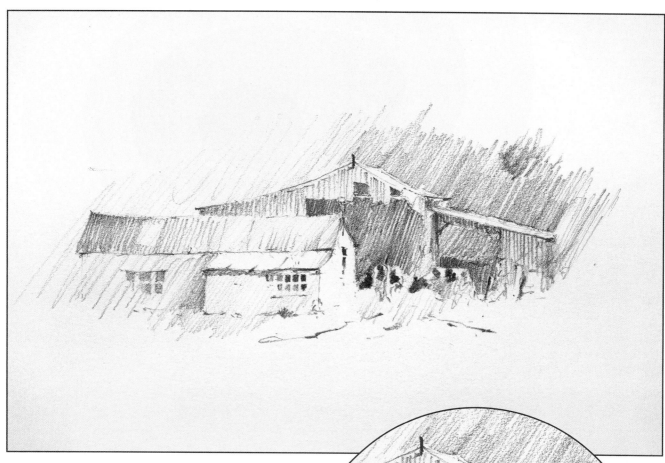

4 Once the front barn is at this stage, it is just about finished. Turn to the details, by adding some strong dark accents to the cows, surrounding windows and posts. You can leave it at this stage, but take a moment to see if you want to develop it further. Here, I feel that the top left of the sketch needs resolving... so in goes the silo.

The focal point for the sketch is well placed, being just off-centre. The mid-toned darks of the barn interior and the rear tree line act to pull the eye over to the right of the sketch.

We then have the darkest darks of the cow's heads set adjacent to the white of the gable end. I have even indicated ruts in the ground that lead to the cows.

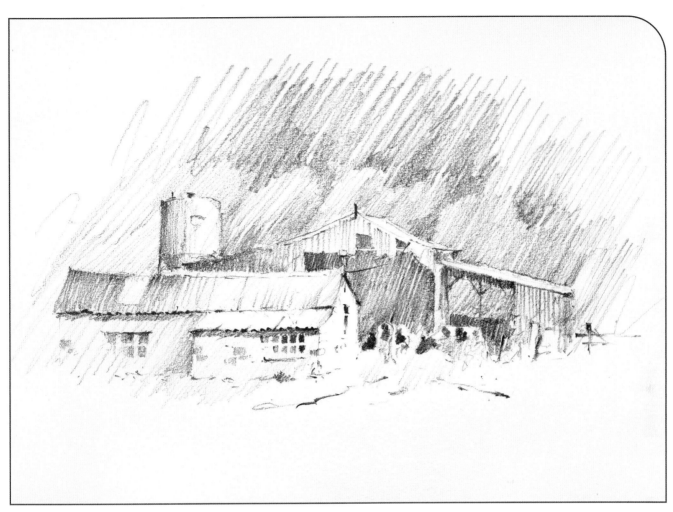

The finished sketch

Did adding the silo work? I think so, as I kept the area close-toned and I feel it adds a much-needed vertical feature to counter the horizontal barns and also a place for the eye to travel to after it has finished with the cows.

Taking liberties

As we become more adept at sketching and seeing, we learn to omit, simplify and even change elements of a scene to make it fit into our inspiration for the sketch.

Compare the photograph to the right with the resulting sketch below. I have omitted the dead tree entirely and turned the stump into a pollarded tree. I have also shown more of the brook and simplified the background – all changes intended to ensure that the bridge of the title was enthroned as the focus.

Would it have been better to have curved the brook into an S in the foreground, thus giving a lovely curved lead-in? Such questions are down to the individual artist's taste.

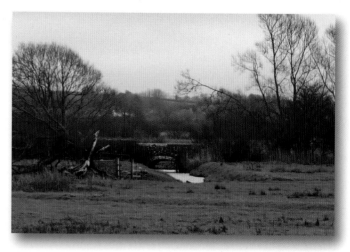

Source photograph

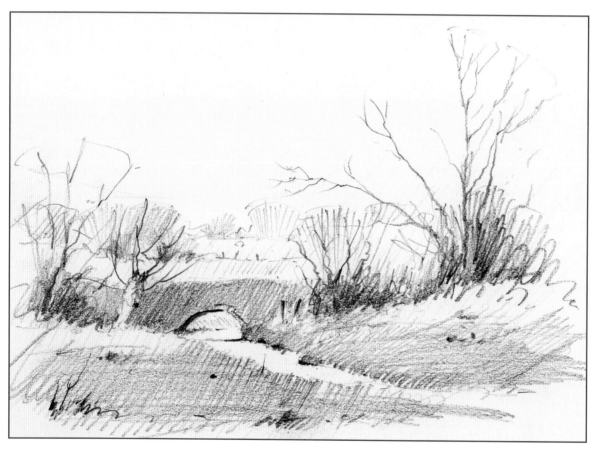

The Little Bridge

Tip

I keep a title in mind for my sketches as I work. This helps me to bring out the focus; and to ensure that what caught my eye is given importance in the sketch.

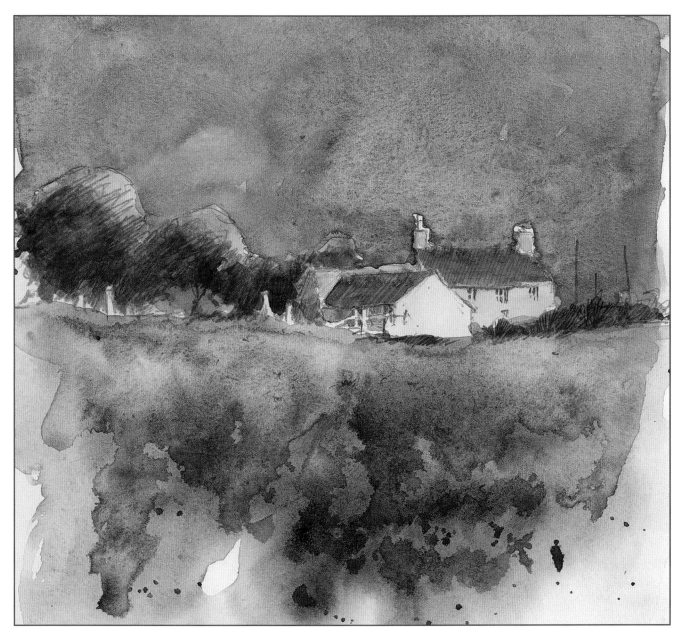

Light Before Rain, St Davids

A small 20 x 20cm (8 x 8in) pencil and watercolour atmosphere sketch to catch the light before the rain. Two cuckoos were sitting on a wire above and, when they flew, they were mobbed by smaller birds.

The pencil was placed first and then some watercolour washes were hastily added.

The photograph did not give me all the information in the sketch. I knew that my primary interest was the light on the buildings and that the foreground and sky were doing nothing to help the composition. Only an hour or so earlier, the sky had been really stormy, and I decided to darken the sky to push the light onto the farm. The foreground was intended to be developed further in an attempt to depict the front hedgerow, but I preferred the initial messy wash and decided to live with the outcome. As we gain experience altering things in this way becomes more and more intuitive, though this admittedly is an extreme example of such a thing.

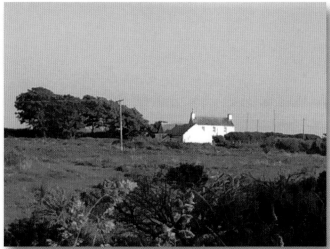

Source photograph

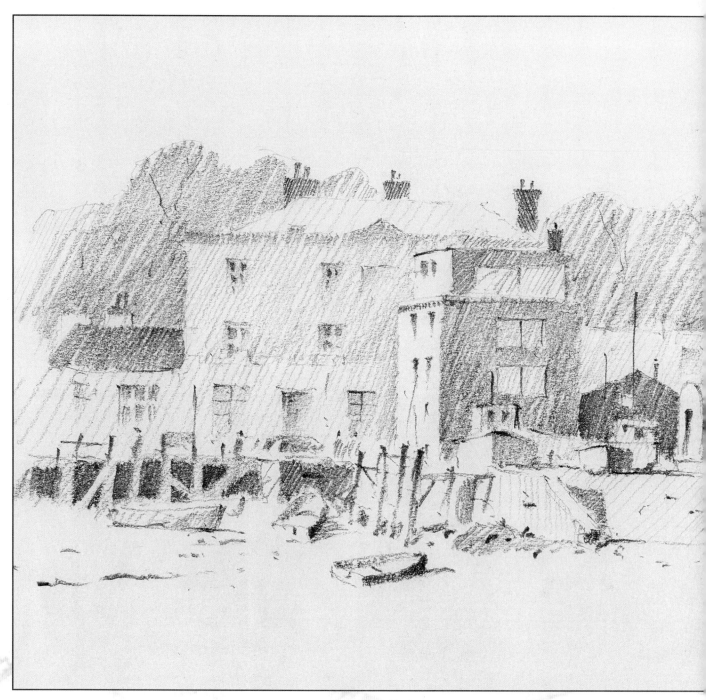

Hythe

In a complicated subject like this it is important to identify what you wish to say. Here it was sunlight and a sense of clutter. Once this had been decided, I identified some dominant horizontals and placed them. It was then a matter of some hatching to separate the horizontals before filling in only necessary detail.

Handling complex subject matter

I have not been shy in informing you that I see the world and all within through the lens of **S.E.T.**, an approach that treats all before you with equal importance, rather than picking out individual objects from a scene. I recognise, however, that this is not necessarily a view shared by the rest of the world's population. The result is the inclusion of this chapter, where we examine how to render some of the more common subjects and features encountered while out with a sketchbook. We shall, of course, relate each to our new philosophy of shapes, edges and tones.

If we sketch the items in this chapter at close hand, then we will probably end up with a 'study' (see page 61), and this is a very useful type of sketch to produce. Most of the time though, we shall be at a given distance from our subject and this may mean that people become crowds, cars become traffic and animals become a herd, for example. We must try to concentrate on seeing **S.E.T.** or our brain will interfere and spoil things.

When handling a complicated subject, we must use all the strings that this book has helped us to create for our bow. In our mind's eye, we need to clearly identify the things we like and want to use in the finished sketch. It will be critical to simplify areas by omitting, joining and fusing shapes.

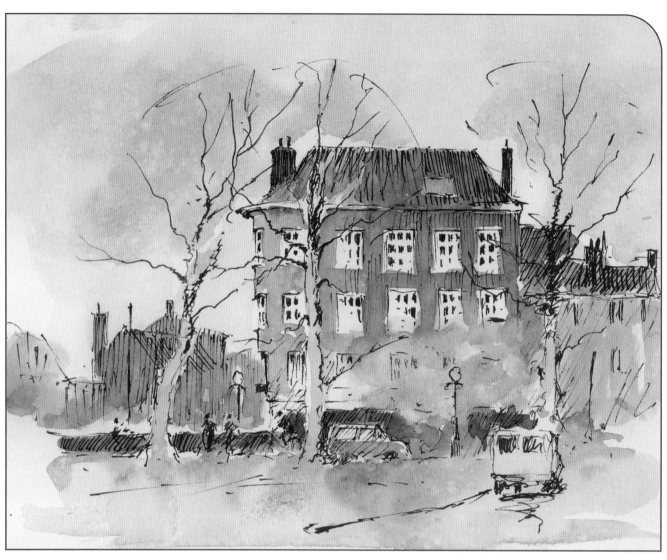

Rain, Bruges

On extremely wet trips I will rely on the camera if I have to, but it was not an option here, the saturating wetness made the digital camera mad and it started doing naughty things or did not work at all. When I look at this pen and wash I immediately feel the mood of that trip. It was not a good time for me personally and I am amazed at how the sketch reflects my own emotions at that time.

Drawing the elements: the importance of weather in your sketch

There are many ways into a complicated picture, to give yourself that first step and get over the paralysing nature of a clean white page. We can start by drawing the focal point and working away from it, simplifying as we travel, but that's quite complicated. Instead, it's probably better to establish some big shapes first, then isolate any white paper by running a light hatch through the piece. If we are working from a photograph, then the place to start may be to crop the image. Prior to all this, however, is deciding on what you want to show – that is, the overall atmosphere you want in the finished sketch.

The atmosphere will be hugely affected by the weather, which affects the quality of shapes, edges and tones.

Let's take a look at how to wrap S.E.T. around the weather. Over the page we are going to take the same scene and sketch it as it would look in sun, rain, mist and snow. It is the knowledge of S.E.T. that will enable us to do this.

Do bear in mind that we can have sun showers, misty snow and sunny snow and other combinations, so the examples on the following pages are just a selection of the scores of different weather effects open to you when we understand the S.E.T. approach.

I shall talk you through the creation of each version with regard to shapes, edges, tones and the method used, then on the following pages you will find a number of further examples of each weather effect.

Indicators

An important part of evoking a particular effect lies in recognizing the key components of that effect, or its 'indicators'. These include consideration such as reflections for rain; fused shapes and soft edges for mist; or strong contrast with shadows for sunlight.

As well as these main indicators we can also include secondary indicators. A boat will suggest water, an umbrella will suggest rain, and a leafless tree, winter. I will often exaggerate the indicator components of a scene to strengthen the 'message' of the sketch. To give an example of this, to exaggerate mist or recession, we might fuse distant shapes together, whilst depleting any detail within the shape and making it fainter than it actually is.

Sun Showers

Look how simply the reflections have been stated and how the rain message is backed up by the umbrella. The strong tonal contrast on the right-hand side building coupled with the 'indicator' shadow off the lamp establishes the sun element of the title.

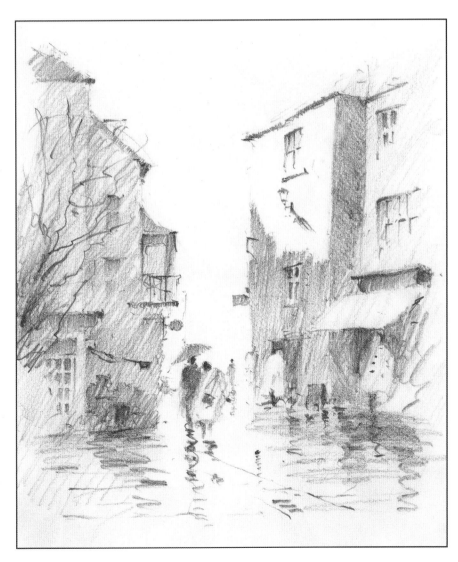

The language of sunlight

The key method to use for sunlight is chasing the shadows (see page 50). This sketch was all about putting in darks next to white paper to catch the high contrast created by bright sunlight. I started on the left and shaded in the shadows to form the shapes. If you are not confident enough to do this, then lightly drawing the big shapes first or taking a line for a walk (see page 26) could be used prior to shading the shadows.

There are a lot of separate shapes in this scene, and I worked hard not to draw lots of outlines, as this would spoil the effect of sunlight. Edges are very hard and staccato, with only a suggestion of softness on the trees and church to suggest recession. White paper and dark tones predominate, with midtones in short supply.

The language of rain

The method used here is 'isolating the whites' (see page 52). It was all about hatching the vertical surfaces of the trees and walls to allow the roofs and road to shine. The church and trees have become one fused shape. The actual wetness is suggested by the horizontal scribbles that I have dragged downward into the roofs and road. The figure with an umbrella is a useful addition to help set the scene – don't be afraid to add one if a handy pedestrian is nowhere to be found.

Shapes in rain are slightly fused, with definition between the walls and the windows less distinct. Edges are softened, though there are still sharper edges visible under the roof eaves and on the figure, for example.

Rain increases the effect of aerial recession (see page 53), so the building on the right has been kept hard-edged in order to push the further building back into the picture plane.

Midtones predominate, with only one or two strong darks. The hatching on the buildings has become progressively stronger and darker. Contrast the tone of the church with that of the house on the right.

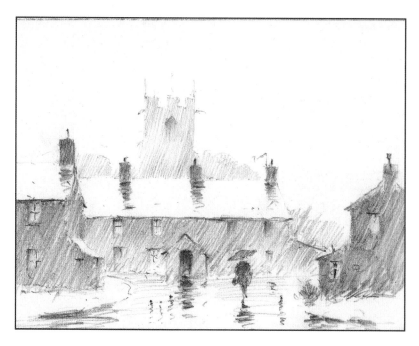

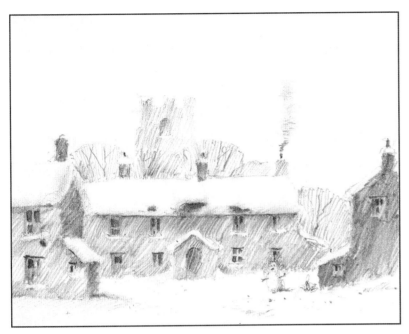

The language of snow

As with rain, isolating the white paper is a good approach for snow. Also similarly to a wet, rainy scene, vertical surfaces in snow will be darker than the flat/sloping surfaces, but snow also creates very different effects and requires a different approach.

The difference is mostly to do with edge quality. Edges that are hard and pointed become softer and rounded under snow. The roofs and the way that the houses meet the ground in this example are evidence of this. Look at the subtle shading to show the depth of the snow on the roofs.

Shapes are similarly affected as those in rain. They can be very sharp if it is also sunny. Horizontal surfaces like paths, roads and grass will obviously merge to form bigger shapes. Tones can vary a lot in a snow scene as it obviously depends on the sky condition. A sunny sky means big contrasts and a cloudy sky will give a closer toned result.

The language of mist

The method that I usually use for mist is the overall hatch (see page 53). I will scribble a light hatch over the surface, often including the sky. I may then do some stronger scribbling in the corners or the foreground if I feel it needs this.

In a scene like this, where there are a lot of fused shapes, you need to work hard not to draw lots of outlines, as this would spoil the misty effect. Edges in mist are very soft and fused, with only a minimum suggestion of separation on the trees and church so as not to spoil the effect of recession.

Tones will predominantly be close, but some surprisingly strong darks may well be visible in the foreground.

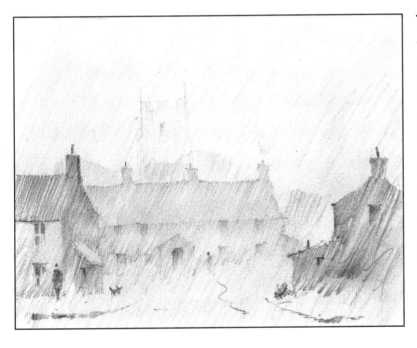

Sunshine

Bright sunlight reflects dazzlingly from objects, so you need to keep the areas of highlight clear. To capture the effect of sunlight, you therefore need to look for the shadows: the darks are your opportunity to bring the light out.

In particular, cast shadows are important to represent sunlight in your picture: these are indicators for the strength of the light.

You will need:

Paper: sketchbook or a piece of cartridge paper

Pens: 0.8 permanent black fineliner

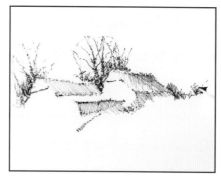

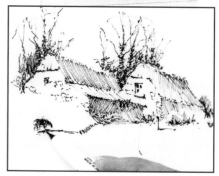

1 Identify the dark shadows. Begin to chase in the basic shape of the darks in the building with light lines. Add tone with hatching; reinforcing the depth where necessary with cross-hatching.

2 With the buildings in place, build up the darks in the foliage. Note the use of counterchange (dark against light) around the roofs of the buildings. Use looser, more free marks.

3 Develop the details across the sketch. Use directional hatching for the cast shadows, as this helps to show that they follow the lie of the land.

Tip
Be sure to add only the shadow sides of the windows: the side in the light will be lost in the dazzle.

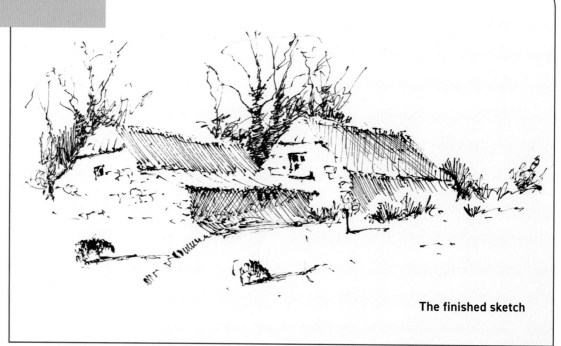

The finished sketch

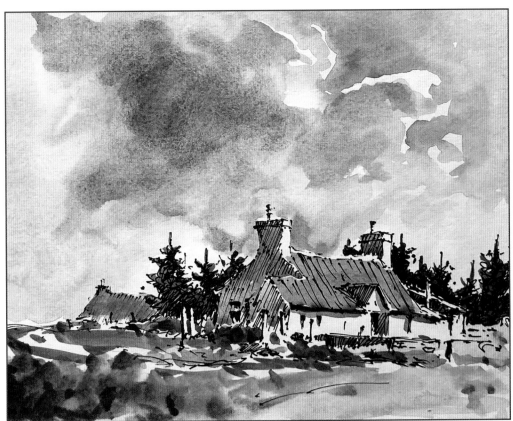

Scottish Cottage

Sunlight enriches colour. I used pen and wash here, because I felt that this particular sketch needed an input of colour. Notice how the sky has been used to pull out the white chimney.

Shadows, Marrakesh

Sketching a scene such as this on location takes all the concentration you can muster and is no easy feat. I tried to draw it with the shadows only but soon realized that I would need a few loose 'chasey' lines, to get a map for the accurate placement of the shadows.

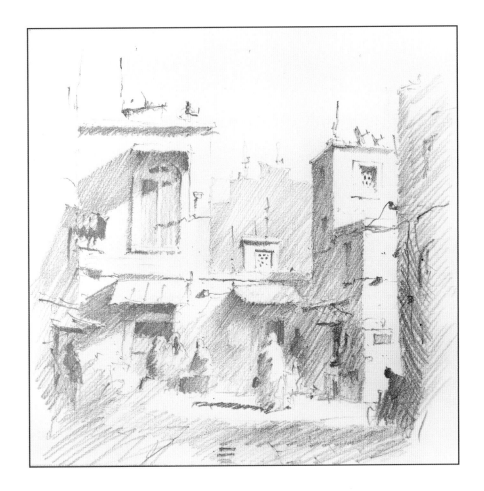

Rain

Flat, hard surfaces like roofs and the road reflect light when wet. This, along with reflections, are the key things to bear in mind when representing rain in a sketch. An overall hatch, sparing only the areas that reflect light, is a great place to start.

You will need:

Paper: sketchbook or a piece of cartridge paper

Pencils: 3B graphite pencil

1 Using a 3B pencil, draw in the roof elements to isolate them as white. You only need very light marks. Next, hatch in the surrounding area, using your finger (see page 44) to fill in the area quickly.

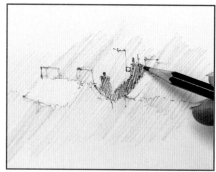

2 Add another layer of shapes. Feel free to adapt and exaggerate shapes that are in front of you if they help to bring the focus to the light areas.

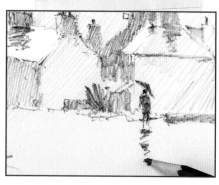

3 Develop the details and then add relections with a horizontal scribbly motion. Give any figures an umbrella to act as an indicator.

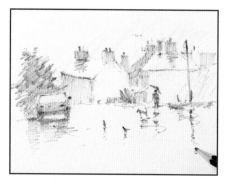

4 Add some small marks in the road's surface – perhaps potholes, perhaps pigeons – anything to break up and add interest to the surface.

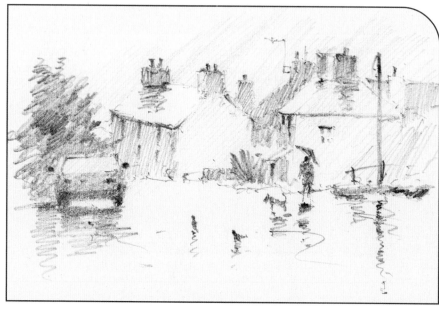

The finished sketch

Note that the details in the foreground – the car, figure, fence, telegraph pole – are all dark. Having stronger tone in the foreground and weaker tone in the background helps to give a sense of depth in the rain.

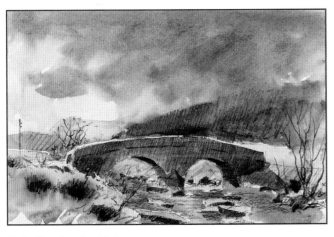

Rain Coming In, Mull

The feeling of wet weather is suggested here by the glowering sky. I felt that colour was important to the mood of this atmosphere sketch; which is why I used pencil and wash.

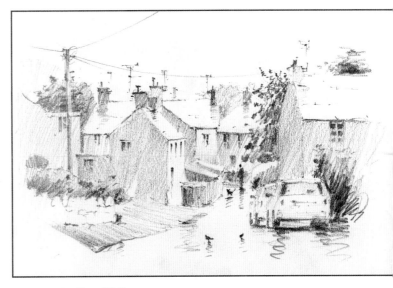

Rain on the Dog Walk

The few passers-by here had a shock at seeing my face peeking through the small open window in the side of the van – but it was the only way I could get the sketch. One or two asked if I was doing teas and coffees – most off-putting.

Notice that we still have white paper and darkest darks.

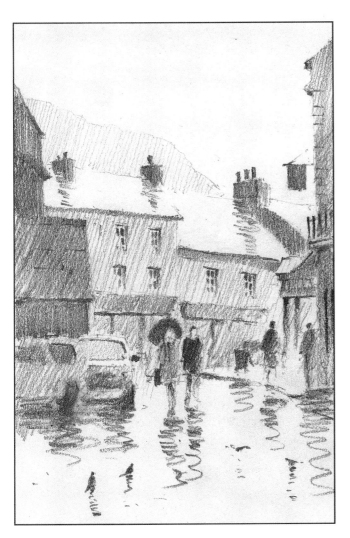

Wet Day in Brecon

I love heavy rain: it has such a dramatic effect on a townscape. The hard surfaces, both inclined and flat, trap enough water for reflections to form.

◼ Snow

Colour makes indicating snow easier, but it is possible to sketch snow effectively by focussing on the quality of edges. Undisturbed snow softens and rounds off corners, so points on roofs, for example, will be obscured and appear rounded.

You will need:

Paper: sketchbook or a piece of cartridge paper

Pencils: 4B graphite pencil

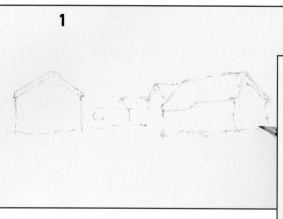

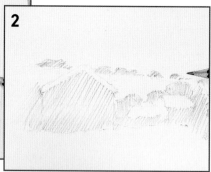

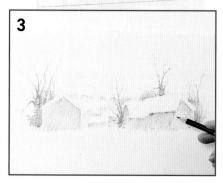

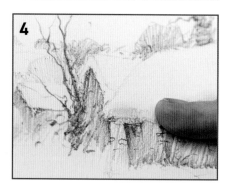

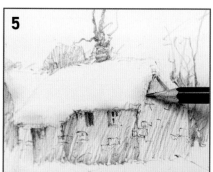

1 Start with a very soft roofline using a 4B pencil, focussing on suggesting soft edges. Draw the buildings down to the ground, then establish a similarly delicate ground line.

2 Build up the tone lightly by hatching off the lines (see page 43), then add a distant hill line and small trees.

3 Strengthen the tone to develop the shapes. This stage is all about pulling the snow out through use of contrast. If necessary, add trees or similar dark shapes to create contrast with the roof. Don't over-strengthen the midground and background. The tone should softly recede.

4 Add detail, then use very subtle shading to add shadow to the snow itself. Use your finger to gently smudge the mark.

5 Re-establish the line beneath the smudge to create the impression of a soft curve. To finish, add soft shadows as indicators across the foreground. Be careful not to overdo this. Keep the majority of the snow's surface bright and clean.

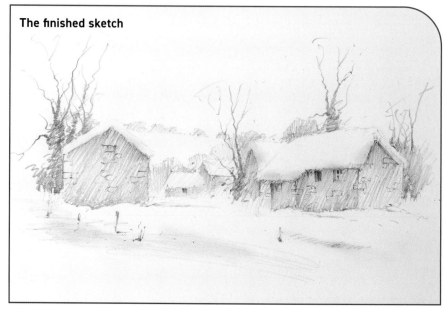

The finished sketch

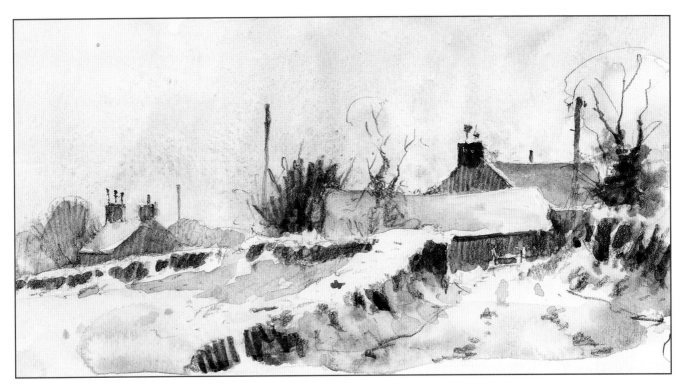

Heavy Snow

A heavy fall of snow found me gingerly crawling around my local lanes in the camper van. I nearly got stuck a few times but found some lovely subjects such as this snow-bound lane with a lazy sun trying to push through the sky.

I often use pencil and wash for snow scenes. The pencil is less harsh than a pen, and the colour makes it easier to get the message across. I tend to use the sky a lot more in snow scenes also, so the watercolour is doubly useful.

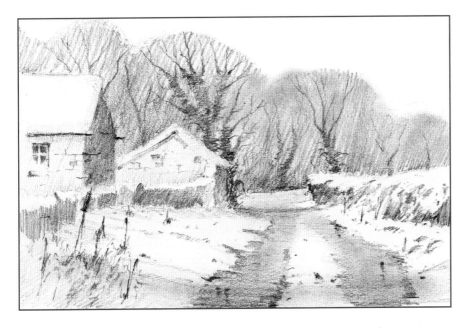

Snow Thaw, Frampton

The more subtle the effect, the more difficult it is to sketch. Snow is like water in that to show it, you tend to sketch the objects around it more than the snow. In this case, however, there is surprisingly little white paper as most of the snow was shaded slightly. In terms of tone, the verticals, such as walls and hedgerows, are quite dark. I felt compelled to smudge the road and tree canopies in places, to get the 'feel' of the day.

Scenes such as this are exceptionally difficult to portray. You must really look closely, and strictly adhere to the shapes, tones, and edges that your eyes can see. Your brain will constantly try and take over. The role of actual observation belongs to the eyes, so keep your brain for planning the sketch: how you wish to compose it, and what you wish to say.

Mist

Misty scenes tend to work well when built up in layers; from light-toned and vaguely-defined distant areas to darker, more clear foreground details. Charcoal is wonderfully suited to this level of subtlety, as you can reinforce or remove it easily. I've used Not surface watercolour paper here for a slight texture.

You will need:

Paper: Not surface watercolour paper

Pencils: charcoal pencil

Other: large and small charcoal sticks

1 Using the side of a large stick of charcoal, block in the main areas of light tone. Leave a negative space for a focal roof – though don't worry if you cover it, as you can easily lift it out with a putty eraser.

2 Using your fingers, smudge in the charcoal to soften the effect and break up any hard marks.

3 Switch to a smaller, finer piece of charcoal to begin to bring in the details. Break up the tone with stronger marks and hint at the distant church tower with a very light touch.

4 Increase the tone as you advance. In the midground, switch to a charcoal pencil to pick out the details.

5 For the foreground river bank, add more charcoal with the side of the small stick and soften it in; then use the small stick and charcoal pencil to chase in some rushes and similar details with strong, clean marks.

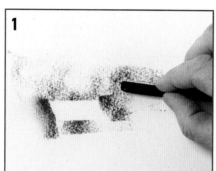

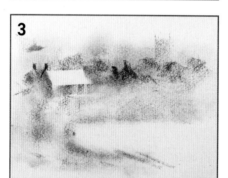

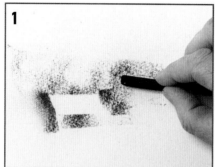

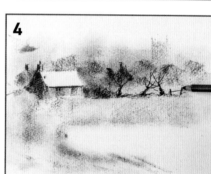

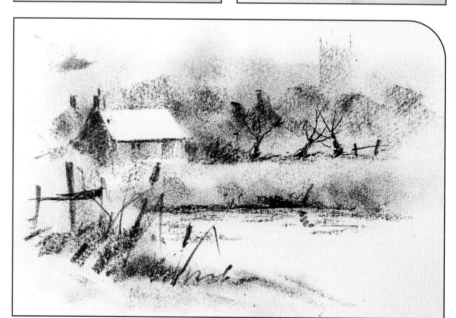

The finished sketch

Flood Near Langport

The town of Langport has been fused and faded into the haze to allow the flooded field to dominate. Would the misty effect have been enhanced if I had smudged the background with my finger?

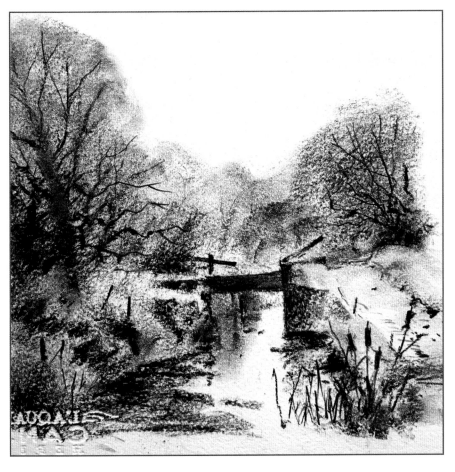

Mist on the Canal

Now redundant, the Neath Canal is slowly returning to nature's arms. I love riding my bike along the towpath on winter days, when it evokes a feeling of melancholy for a bygone age.

Charcoal is a fine medium for the portrayal of fog and mist. Its smudgeability makes soft, diffuse edges easy, and good darks are available too.

■ People

Like all the subjects in this chapter, the way people appear will vary depending on the light, distance and angle from which they are viewed. If you study people for any amount of time, you will soon notice that your best efforts will not be your most detailed, but rather the ones where you have caught the pose and the proportions. Here are some sketches with figures and some tips to help you to get started.

Sketching figures: starting points

Here are some basic shapes to look for when observing figures in the landscape. Practising these will give you the ability to get the basic proportions correct; and are easily adapted to the actual figure before you.

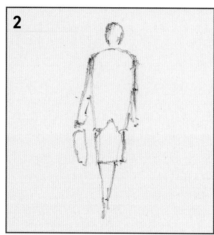

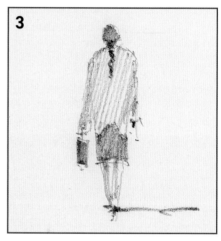

1 Place a light carrot shape on the paper.

2 Add the head (not too big) and dress the figure.

3 Add some tone and attach the figure to the ground with a shadow or reflection.

1 Write a capital M above a capital W.

2 Add the head (again, not too large) and make each end of the M an arm.

3 Construct the legs from the W, and add tone.

Distant figures

Figures are virtually essential in a town scene, unless you deliberately wish to portray a quiet street or early morning feel. They populate the scene and make it much more convincing.

Figures should be treated as any other part of the scene; in simple terms of shapes, edges and tones. Emphasis is best placed on the heads and upper body, with the legs merely suggested. This helps them to fit into the scene.

As the details below show, Some are dark and others are light. There is a suggestion of a bag and, if you look closely, someone on a bicycle. These observations of small differences between figures are essential if a formulaic 'one size fits all' approach is to be avoided.

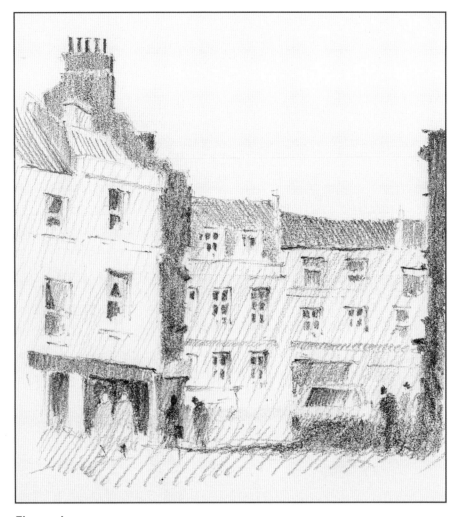

Figures in a scene

The figures in this townscape blend nicely into the scene. We must be able to 'lose and find' figures by softening legs and other parts where appropriate. This makes them emerge from the page and avoids a stuck-on look.

 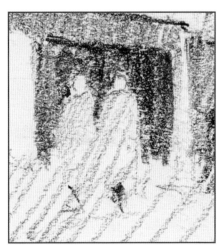

Active figures

Of course, figures in your sketches will rarely, if ever, be facing towards you. Here's where the scribbling technique shows its strength. Rather than looking at details, here we aim to capture the figure's overall shape in one swift scribble. Once that's in place, it's easy to hint at the remaining details.

1 Scribble in the basic shape, tapering off towards the legs.

2 Add the head and limbs. Do this lightly and you can adjust them until they look right.

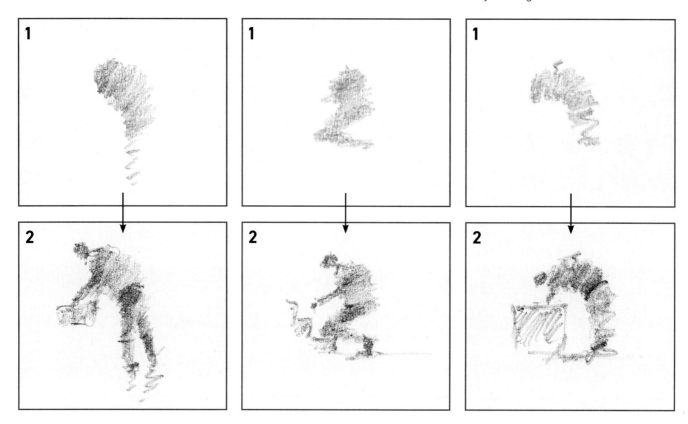

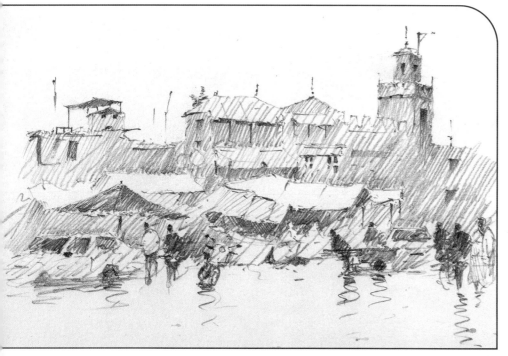

Marrakesh Rain

When we go away with friends, I insist on choosing the cafés with the best view. This sketch involved two dominant horizontals, the roof line and the canopy line.

There were so many figures and they were all moving so rapidly that I resorted to the scribble method (see pages 24–25) to suggest their active nature. Perhaps related to the level of focus needed, making this sketch took about the same amount of time as it takes for a coffee to go cold.

Individuals

When sketching individuals, you may need to work quickly. Place the emphasis on getting the right stance and proportion, rather than detail.

Figures such as those below are great source material for paintings and more complex townscapes. These sketches were gathered at an airport, but you could try a street, café or park – in fact, anywhere where people pass by or gather.

Groups

When drawing groups of figures, the spaces between the individuals become a very helpful tool in gauging accuracy and establishing the relationships of size, shape and so forth between each figure.

Don't be afraid to use ghost lines to make negative shapes that allow you to more easily judge proportion at a distance. Groups of figures become a mass of heads and shoulders and the lower parts of their bodies and legs often appear fused.

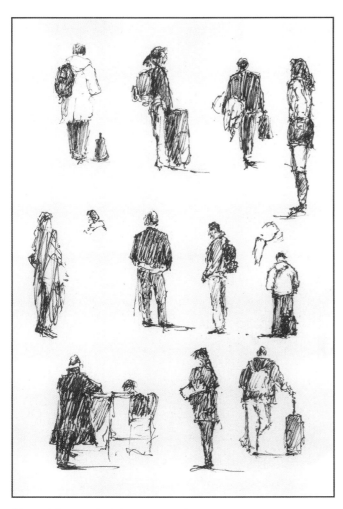

Airport figure sketches
Airport check-in desks are a good place to practise figures as they are static for a long time. While making this sketch, two Italian policemen came to check me out, but thankfully decided that it didn't warrant a full strip search!

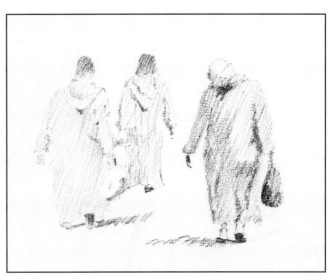

Shoppers, Marrakesh
I'll often do quick studies of people if I am stuck in a place for some reason and nothing else presents itself. These are separate individual sketches, but I drew them all on the same page.

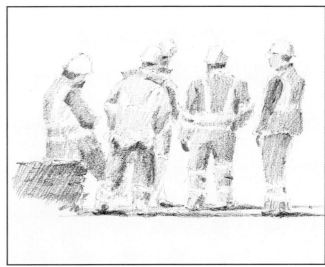

Baldwin's Men
It is not cheating to take a photograph – just less pleasurable. Here, I felt that it was necessary to freeze the group for long enough to get a fairly accurate study completed.

Water features

It is surprising how often water will draw itself. It is insinuated by the shapes around or on it, and in most cases as little pencil as possible should be used. We can often get away with a few ill-defined squiggles.

If, however, we are dealing with waterfalls or waves, then more work will be required. It is very hard to draw moving water, and if sketching on site, it pays to watch for a while and try to discern a pattern. Waves, waterfalls and ripples will all form some form of natural pattern of shapes, edges and tones.

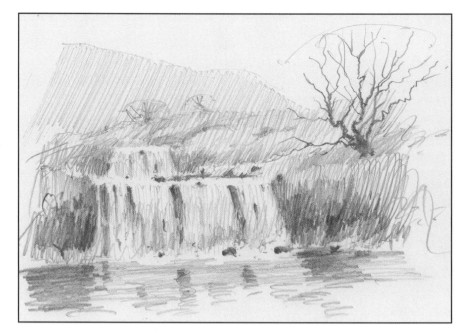

Waterfall in the Black Mountains

I indicated the tops of the waterfalls and laid in an overall hatch to isolate the white tops of the falls. It surprised me how dark the 'white' falling water was, due to the shade it was in.

It was then a case of layering ever-darker hatches – often with squinted eyes to simplify the view – to produce the form in the hills and water. I left the tree until the end, as a type of treat to myself.

The sea

Waves will always be darker underneath the roll of the wave than on top where the light can strike.

In this study, notice how simply the distant wave has been placed and how the white froth in front of the wave has been indicated. It is of course a study of many waves; just as in the waterfall sketch above, we are drawing the pattern of the water, rather than isolating a section.

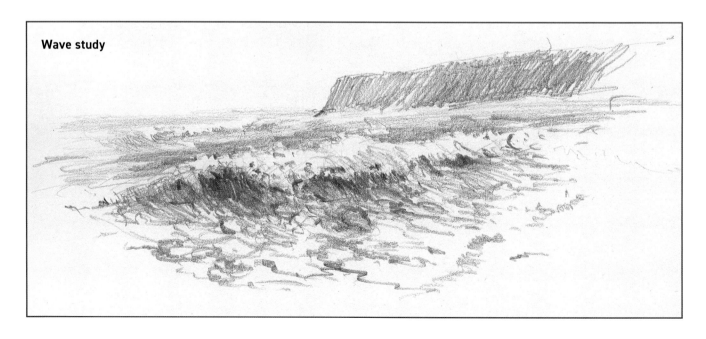

Wave study

Reflections

As you can see from these pages, I treat reflections very simply. A random horizontal squiggle is sufficient for most instances. It is useful to know that reflections are usually more solid near the object causing the reflection and that they break up the further away they travel. It is very important to keep your marks horizontal, as sloping squiggles indicate a sloping water plane, and will never convince.

If it is your wish to execute more detailed reflections, then you will simply need to study the shapes, edges, and tones involved in the given reflection – treat it like any other part of the sketch.

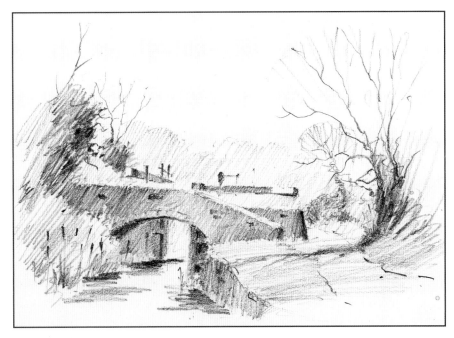

Canal Bridge
Often water is suggested by the very nature of the scene, such as here, where a horizontal squiggle of hatching is all that was placed to give form to the water.

Venice
Notice how little has been done to the water in this atmospheric sketch. The presence of the boats and some reflections are all that's required.

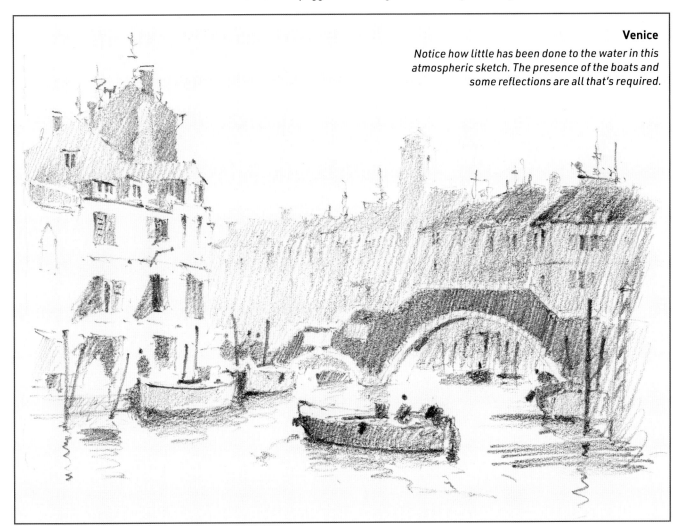

Boats and harbours

I'm a council member of the Royal Society of Marine Artists in the UK, so it would follow that boats and harbours are among my favourite subjects. Harbours can be very busy in terms of shape, and it is important to find those dominant horizontals that we talked about way back in the beginning of the book (see page 26).

 As with towns and cities, I suggest starting small. A harbour corner with one or two boats is more than enough of a challenge to begin with.

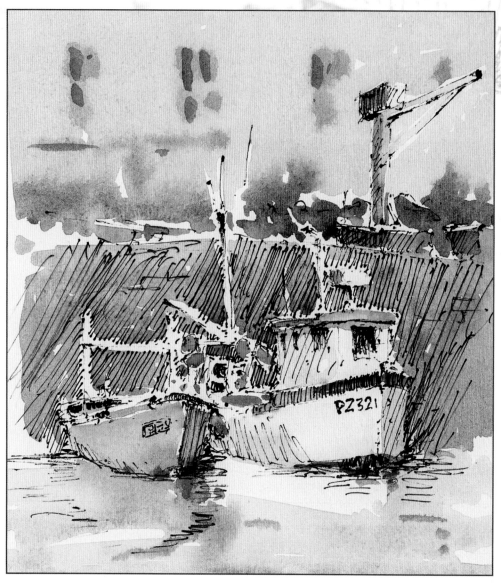

Two Boats, Porthleven

This pen and wash sketch was about the colour of the boats and their interaction with the water. The boats have been quite loosely sketched in, along with the backdrop, and the colours have been well thought through. If you place your hand over the busyness above the harbour wall, I think the message is even better.

Simple starting points for boats

Objects look different in different weather. They also look very different depending on the viewpoint we choose, so there is no 'magic' way to draw boats, buildings and similar objects. There is no real substitute for sound observation of shapes, edges, and tones, but as with figures, some basic guidance can be useful to build confidence and experience, and help you recognize shape. Here are three ways to arrive at a basic boat shape.

Brick-based

 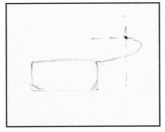 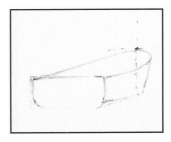 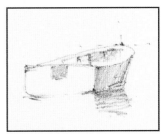

1 Indicate a brick-shaped oblong with a light line. Place a dot a little higher and to the right. This will be the bow.

2 Swing a line for the near side of the boat. It must go outside the vertical ghost line then dart back in to join the dot.

3 Add the remaining lines. The other side of the boat will appear far less curved than the near side.

4 Add some shading to give the boat a three-dimensional look.

Wedge-based

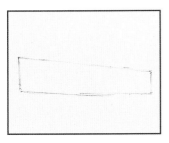 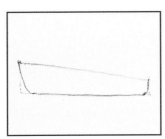 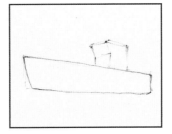 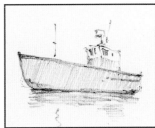

1 Draw a truncated wedge shape – think of a brick with a sloping top.

2 Draw in a slightly sloping bow and form the rest of the shape from the wedge.

3 Add a cab on top of the boat to give it a three-dimensional quality.

4 Shade the boat and attach it to the water.

Figure of eight-based

 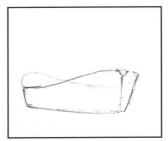 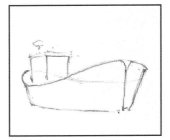 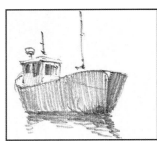

1 Draw a loose figure of eight on its side: it will look like a bow-tie shape.

2 Form the hull of the boat below the bow-tie as shown.

3 Add a cab and other superstructure as required.

4 Add form by shading your boat.

Boat studies

I could draw boat studies forever. There is such diversity of shape, size and form.

As noted earlier, a study sketch may contain both the object of the study and its immediate environment – the latter is particularly important with boats, as they are intimately connected to the water below.

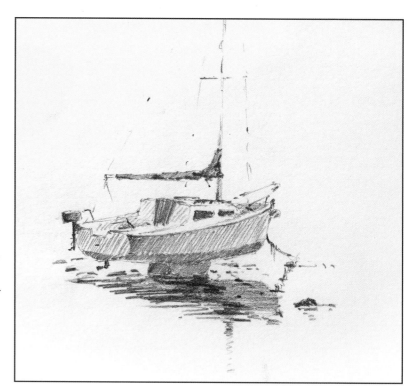

Boat study

This sketch is the type I make to get to know not just the object – in this case a boat – but its context as well.

Boats in Essaouira

I felt that the bulky shapes of the boat hulls made for a powerful composition so I cropped the composition to omit the bow of the front boat. Would it be improved by the addition of a third hull?

Boat study

Here is a little study of a coaster. I learnt a lot about simplification and accents while sketching this.

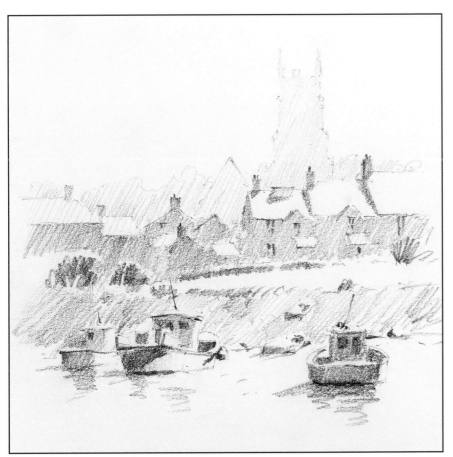

Boats at Aberaeron

Here the main interest was the light on the roofs of the houses, so the boats have been set up to overlap and point into the focal area. The stronger darks used for parts of their shape ensure that the eye rests here before heading off into the buildings.

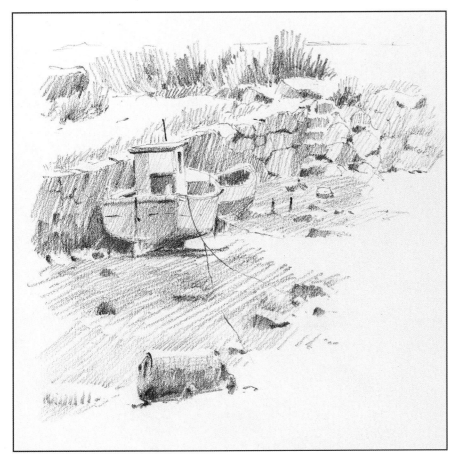

Connemara, Ireland

My idea of sketching heaven. In the middle of nowhere, with nothing but a soft pencil, a sketchbook, and the sounds – and smells – of nature.

Animals

Animals are a necessary part of the sketcher's repertoire, but their toilet instincts aren't good, and this can be a nuisance. How they manage to put out the back more than they put in the front, I don't know, but they do!

As with people, its important to get the basic shape right, cows are far more 'boxy' than sheep for example. If you are close enough to see the legs, then be sure to look at the negative shapes between them. Once again here I show some basic tips to give you a way in to your sketch, along with some of my own work to show the animals in context.

Sheep study

To facilitate a study to this level of finish, I had to use a photograph. Notice that it contains darkest darks, white paper, hard and soft edges and negative shapes between the legs. So S.E.T. still applies here.

Goat study

Remember, whether you are sketching a goat, a car, a tree or a rainstorm... it's always a collection of shapes, edges, and tone.

Distant animals

When placing animals in the landscape at any distance, we only need to get the basic shape and characteristics correct. If you carry out enough studies of the animal, you will develop a 'feel' for what looks right.

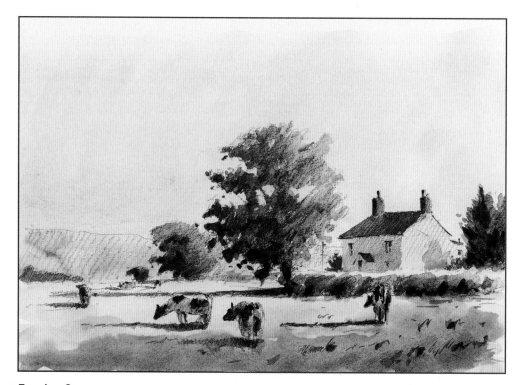

Evening Sun

I had spent the day taking a course in the hills above Abergavenny when I stumbled upon this on my evening stroll. I sat down on my little stool and recorded the scene. I didn't see a soul, and only the gentle noises of summer kept me company.

Herd animals

In any field of cows (sheep, alpacas or any other herd) there will be a number of animals striking a similar pose, so when your starter animal moves, look quickly for another in that pose. Ideally, you should have two or three poses on the go at the same time.

We could, of course, just take a photograph (and sometimes I do) but the direct method leads to the creation of a looser sketch and better understanding.

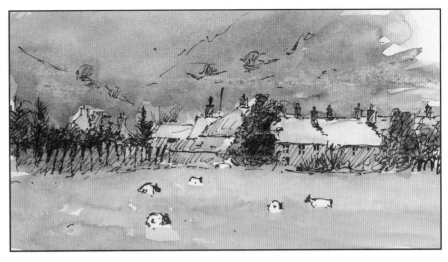

Cwm Penmachno

Varying the poses in a scene makes for a more naturalistic appearance, allowing the animals to complement your focal point, rather than distract from it.

Animal study in pen

When studying live animals in a field we have to go for the pose and stance as they are inevitably moving. Working from a photograph offers an opportunity for a more detailed study.

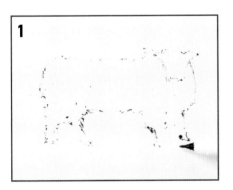

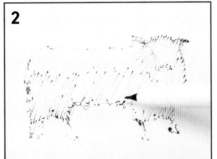

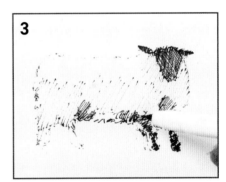

1 Use a 0.8 fineliner at a shallow angle to create the broad shape of the animal.

2 Keeping it at a shallow angle, quickly hatch in midtones.

3 Bring the pen up to a mid-angle and use cross-hatching to build up the tone on the head and fleece.

4 Build up the legs and cast shadow in the same way. Shadows are important to 'ground' the animal in a broader sketch, and are also effective in studies like this.

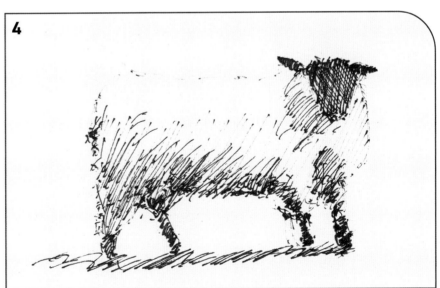

■ Trees

I have always been passionately in love with the countryside and the ever-increasing loss of habitat and species troubles me deeply. For me it's nature that makes me alive, without it, what's the point?

There is joy to be had from taking your sketchbook into the countryside, at all times of the year, and in all weathers. The type of subject material available is huge and there should be something to suit everyone's pencil. Trees are often the landscape artist's muse, and add so much to other aspects of the broader countryside, such as water features and hills, which are covered in other parts of this chapter.

Tree studies

It is important to go for the general character of a tree (big shapes first) as they are too complex to render every twig and leaf. So, in a winter specimen, go for the main boughs and branches and make up the impression of a mass of twigs with a fine hatch.

For a summer specimen, hatch in the overall outline shape with a lighter and darker side. Don't be afraid to separate clumps of leaves from the parent tree as this will help to achieve a broken canopy edge. Without this summer trees will turn very 'lollipop' in form.

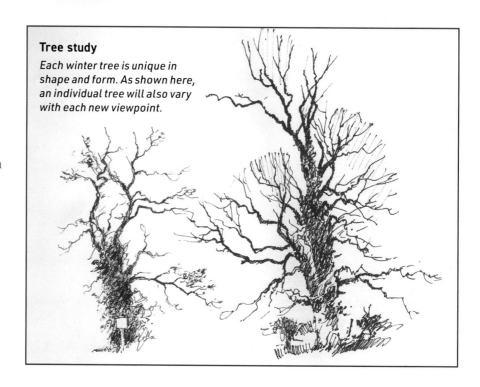

Tree study
Each winter tree is unique in shape and form. As shown here, an individual tree will also vary with each new viewpoint.

Making trees grow

My young daughters would draw me as a big round head, with stick arms and legs coming straight out of the head – quite alarming really. They did this for the same reason that fully mature adults draw a big oversize tree trunk with little twiglets sticking out. Because it's the easiest part for the eye to recognize and focus on, we tend to exaggerate its dimensions.

 Below is a little experiment for you to try. It will ensure that you never again draw those shocking 'fire-damaged' trees that we see in a novice's sketchbook.

1 Draw two very light and loose grids. You don't need many lines, the squares should be different sizes and there is no special number of lines to draw.

2 Place the trunk. The rule from here is that each time you touch a line of the grid, you must split the trunk and make it thinner.

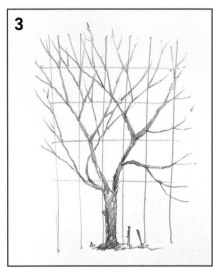

3 Continue upwards, crossing and splitting the branches as your lines touch part of the grid.

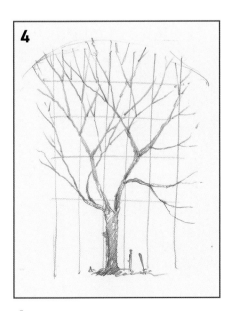

4 Form a rounded crown at the top.

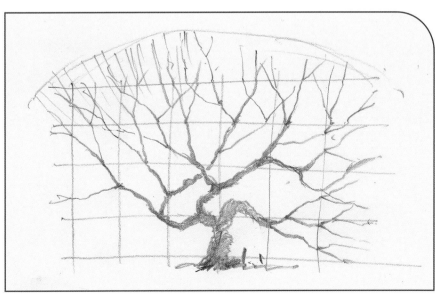

The same principles can be applied to any shape of tree, simply by altering the shape of the initial grid.

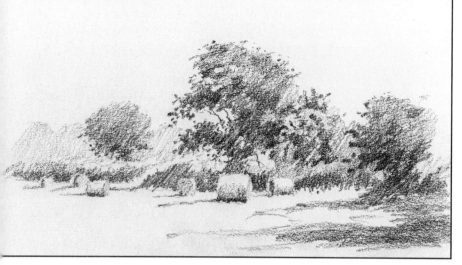

Keep your eyes open. As you build your experience, you will get an eye for a good location. I had dropped the van off at the local garage for a service and was walking back home when I came across this. A favourite of mine, this spot will provide me with a sketch at virtually any time of year and in any weather.

Trees in context

I love trees of all shapes and sizes (so does my dog – but in a different way). Trees in a landscape add both wonderful verticals, and, by way of shadows, also horizontals. They show the time of year and are wonderful for the illusion of depth in the landscape.

When sketching masses of trees, I try to work with an overall hatch and then tease only as much detail out as I require. They contain a wide range of tone from darkest darks to white paper and edges can be staccato or soft. It is more important to look out for these aspects than to struggle to build often irrelevant detail.

As they recede, both winter and summer trees can be fused into one shape with the top of the shape used against the sky or background to suggest a treeline.

Very Early Morning, Glastonbury

Sometimes I feel a bit of colour is necessary to convey the mood that I am trying to invoke. The handling of the trees was very important to this sketch, and a variety of treatments have been used in their rendition. They act as a set of stepping stones through the composition with the strongly-toned foreground tree pushing out of the side and top of the frame to accentuate the recession.

As an aside, look how simply the puddle on the road has been rendered.

Distant trees

These are one fused shape with a medium strength cerulean blue wash added straight into the sky, hence the soft edge.

Midground trees

I have gone for a touch of raw sienna to the midground trees, but it is mostly burnt umber and cobalt blue, which gives me a good midtoned dark.

Foreground trees

Strong hatching and an equally strong mix of burnt umber with ultramarine blue created a powerful dark for the foreground tree. It was important to break up the edge of this tree with lots of twigs, to avoid it becoming very hard-edged and 'cut out' in appearance.

126

Summer trees

Summer trees are about tone and edge quality. The very distant trees have been handled as one pale shape, but as they get closer the tones become stronger and more contrasting (in sunlight, at least), while the edge quality become increasingly broken and jagged.

Trees Down to the Meadow

I love the countryside. Look how peaceful this makes you feel (I hope). It's a good composition because we can see around the bend, into the meadow and away into the distance. It was a pleasure to sketch and involved teasing stronger, more resolved hatches from the lighter underlying layers of hatching used to feel my way to the composition.

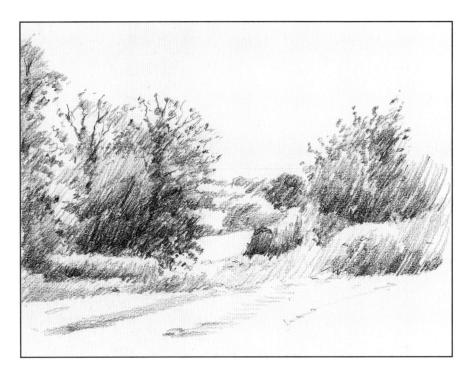

Different species of trees

For the representation of the foliage on some species of tree I use a more directional hatch. Pine trees like those here are a case in point.

I find it helpful to try and follow the growth direction of the leaves, and for a conifer I will often scribble outwards in true Christmas tree fashion.

This detail shows how the trees emerge from a basic scribbled hatch. Note how the branches emerge and disappear within the hatching, as they are obscured.

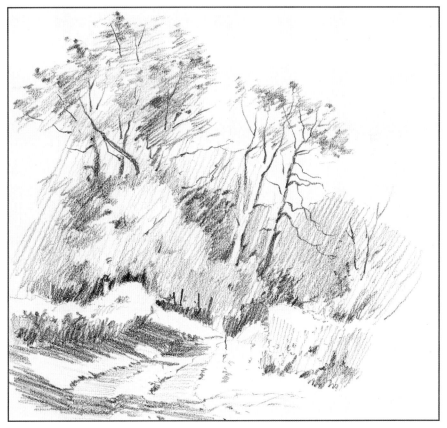

Evening Lane, Llanddewi Rhydderch

The shadows here give form to the lane by way of directional hatching. The Caledonian pines were leaning nicely and the trunks were lit by the evening sun, which was also trailing shadows across the lane and lighting the top of the hedgerows.

Rocky coastlines and hills

I am lucky enough to live right next to quite a varied coastline and it's always a great place to look for subjects. There are beaches, cliffs, estuaries and of course, my favourite place, harbours.

I like the hills and mountains but rarely sketch the mountains themselves, preferring to home in on a human element such as a farm or bridge for example. Sketching in the hills can often take us a fair distance from our vehicles, so the lightweight nature of sketching kit makes it an ideal companion. Atmosphere often plays a big part in mountain and coastal sketching so I will often use pencil and wash to establish a broad mood.

Old Man of Storr

Whatever the subject, the thought process is always the same: What do I want to say? Where are the dominant horizontals? Where are the lightest lights and darkest darks? Ask yourself these questions and you will quickly find a route into the scene.

This was a frantic effort, and I'm not even sure if it was worth putting the pencil work down for the darks, as the wash has obliterated it.

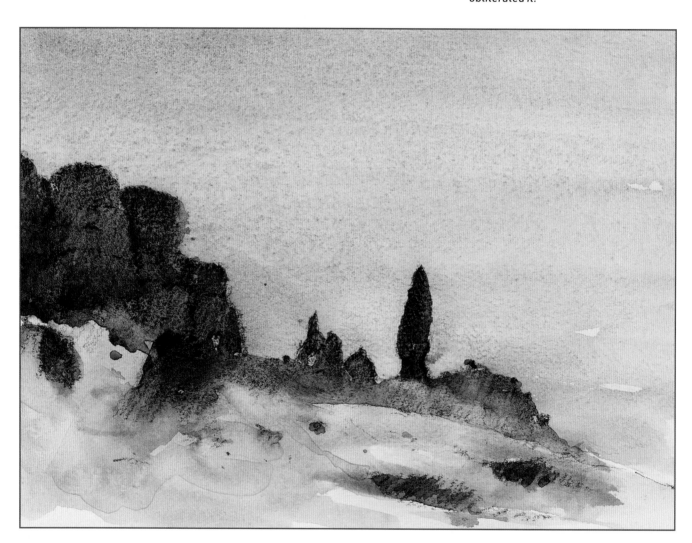

Rocky textures

Cliffs are an excellent example of where to use both an overall hatch and the lost and found technique. It is very important to try to adhere to the 'big shapes first' approach or your sketch will become a mass of lines and marks as you try to render every crag and crevice. Having a strong title (your reason for making the sketch) helps too. If your title is 'cave in the cliff face' then this is the area where detail should be concentrated: other areas of the cliff should be subdued, simplified or vignetted.

1 Use a 3B pencil to lightly draw the cliff profile.

2 Use a gentle overall hatch over the whole of the cliff to pull it away from the sky. You might find it speedier to turn the whole sketch and use your finger to help keep the line clean.

3 Develop the cliff with more line work and mid- to dark-toned hatching creating a lost and found effect within the strata.

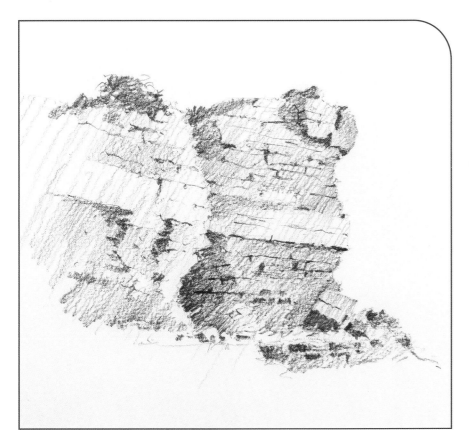

The finished sketch

Towns and cities

I prefer older built-up areas to new developments, but with the right weather and lighting conditions it's possible to find subject matter in any built environment.

I'm not a huge fan of excessive detail, but love to fuse the shapes or concentrate on rooflines in my sketches. I find this a good approach to take, as built-up areas can contain myriad details, and morphing from an artist into an architect is an ever-present danger. Once again the sound advice at the start of this book with regard to big shapes, dominant horizontals and simplification will be essential if you are to survive the experience. Think about overall hatches before trying to tackle every window and door too. The good news is that with just a sketchbook and pencil it's easy to tuck oneself away and go unnoticed, especially in busier tourist areas.

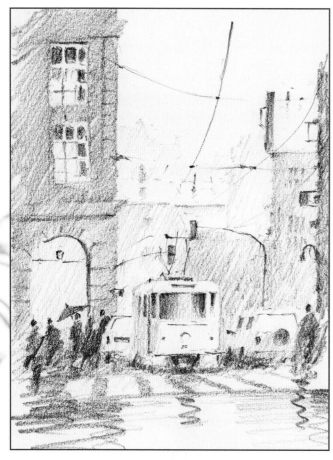

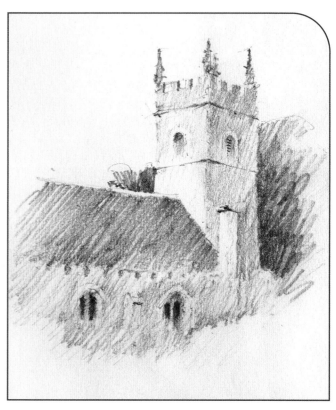

A Suffolk Church

This was a doodle that I carried out while waiting for some students to arrive. There is some very subtle hatching here, and although it's an architectural subject, there is virtually no line work visible.

Prague Tram

An overall hatch went in around the tram which was left as white paper. Everything is fused with lost-and-found edges. Imagine how difficult it would have been to render this scene if I had insisted on trying to include all the detail that I could actually see – but it would not have improved the sketch one bit.

Always aim to include the elements that catch your eye, while depleting and simplifying those that do not.

Simplifying the city

We don't have to go for detail in urban scenes. This little exercise illustrates how to hone down the multiplicity of shapes that we see in built-up areas and still produce an effective sketch.

The sketch here could be further developed by the addition of more windows. You could even introduce another dominant horizontal at traffic level to make things still easier to judge.

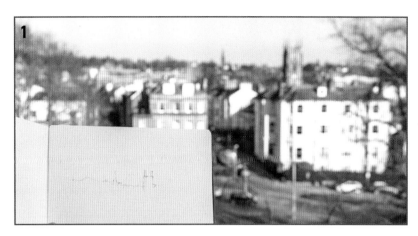

1 Lightly draw in the dominant horizontal shape formed by the skyline.

2 Produce another dominant horizontal, this time composed of a selection of roofs and chimneys that catch your eye.

3 With these reference lines in place, it is now time for some tone. Fuse the distant shapes but use a more selective approach to the shading below the second horizontal, breaking it up to suggest individual roofs and chimneys.

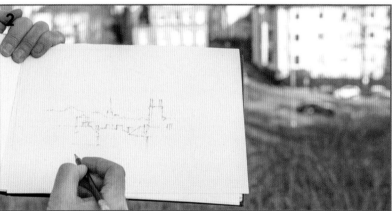

Street scenes

Sketching street scenes can be an exciting thing to do. The first order of business is choosing a place to stand, or sit. I find it best to tuck myself away and lean back onto a lamppost or wall. I can then rest the pad on my forearm and sketch away quite happily.

In the sketch itself, look for good profiles or good shadow patterns/travelling darks (see page 50). Doing this will also help you to avoid excess detail. Try to treat crowds and traffic as mass shapes and start them with a travelling pencil line (dominant horizontals). You can always separate the odd person or car later. As with cliffs, decide on a title to give yourself an aim for the sketch and try to draw towards this without getting bogged down in detail elsewhere.

Back Street, Marrakesh

This looks complicated, but the place to start was with the white paper. I drew the white shapes on the front of the right-hand buildings, followed by the skyline and then lightly hatched everything else away, leaving the lit building fronts clean. I could then place the shadow sides of the lit buildings before adding the dark building to the left side. It took a little while longer after that to add all the detail and bric-a-brac that make these places so interesting to sketch.

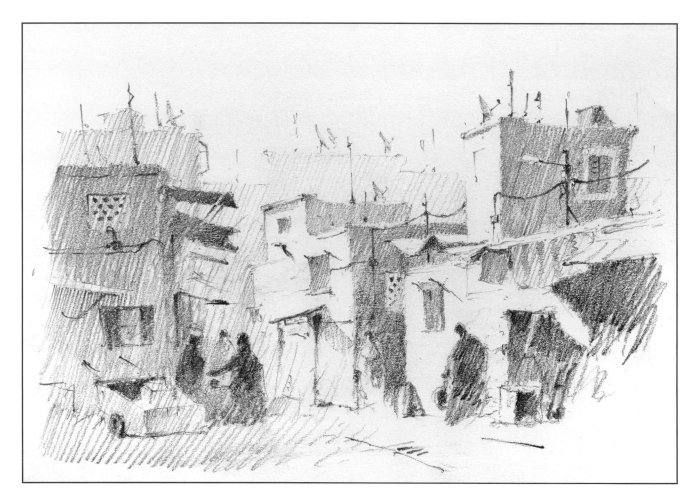

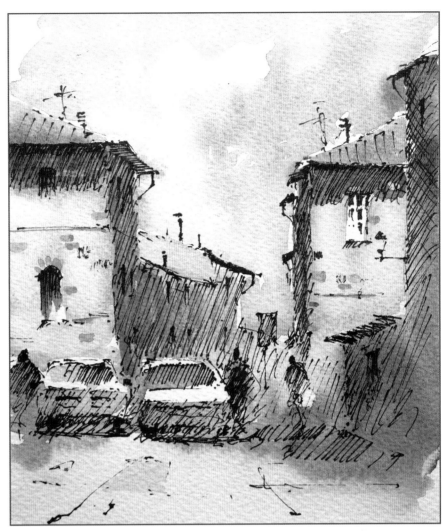

Colle di Val d'Elsa

Although this is a pen and wash on watercolour paper, it is still sketched as I would with a pencil. I have simply run a continuous hatch through all the shadow areas – a travelling dark (in fact, you can see how I approached a pencil sketch of the same town with this technique on page 51). This is a good way to quickly simplify a complex scene.

A watercolour wash was then run through the sky and down through the buildings. Notice that I left little white gaps between the sky and buildings (see detail, top). As well as suggesting bright highlights, leaving dry gaps helped to prevent the building colour from pushing into the sky where both washes touched. When the washes were just about dry, I added a wash of darker colour over the shadowed areas (see detail, bottom).

Vehicles and transport

Don't just draw vehicles to fill spaces or because they were there, try to ensure that they have a role to play in the composition, as in the examples here. In *Hokitika*, right, the cars have been used to link the foreground into the midground focal point (the church).

Hokitika

Car study

Rather than wasting my life on car studies, I used to do them while waiting to pick my daughters up from various activities. I could not help but notice that the distance between the rear windscreen and the ground on most cars is three times the windscreen height. Most novices make it two at most.

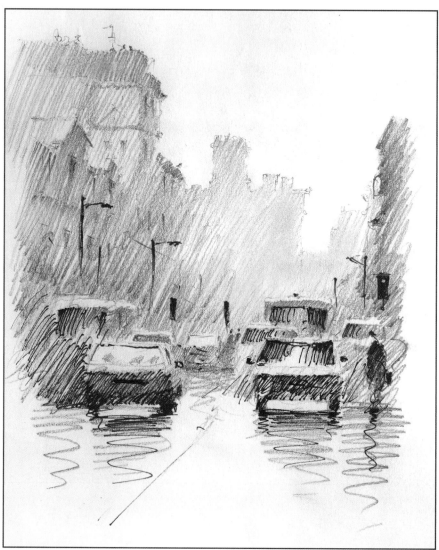

Wet Evening, Cardiff

A frantic, fused effort, that attempts to show a wet evening rush hour, and another interchange sketch with the umbrella handle threaded down the inside of my coat and tucked into the top of my trousers. It was a bit painful every time the wind blew, but I survived long enough to add the pen later in a nice warm café.

Aeroplanes and airports

The nature of airports is that we spend a long time just hanging around. If we have a sketchbook though, this need not be boring wasted time.

It may not be everyone's idea of the picturesque but subjects abound in such places. If I have to catch an internal bus to travel across the airport, then I use my tablet for quick 'ground level' photographs that I can sketch once sat comfortably in the terminal.

If you can see the actual planes, then these make challenging, but ideal subjects, especially with all the associated paraphernalia.

Schiphol Airport

Schiphol is good for sketching views of aeroplanes – and if the armed guards leave you alone, then one is almost hoping for delays... well, maybe not.

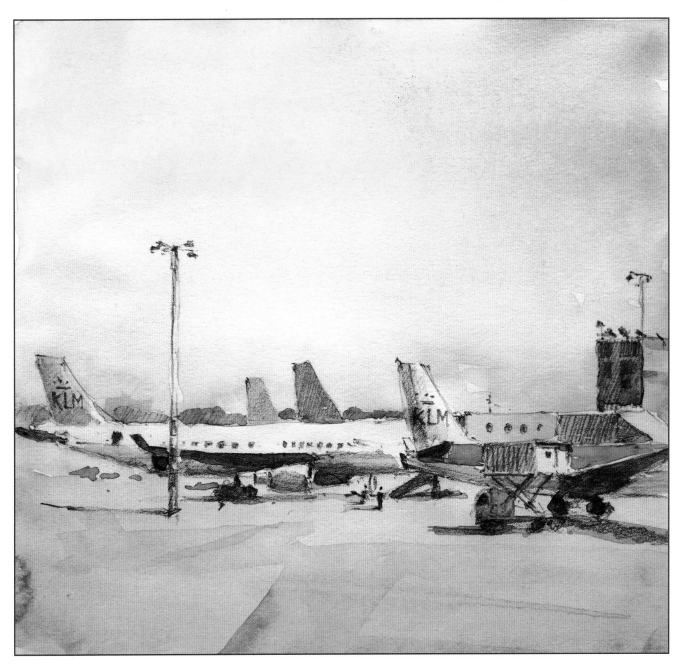

Industrial scenes

I must confess that I have a soft spot for industrial subject matter. I spent twenty years in one of the world's largest steel plants and would often turn up for meetings early with a few blank sheets of paper in my clipboard for a quick sketch. While the UK countryside, coast and nicer towns are usually considered desirable places to spend a day sketching, industrial areas are more of an acquired taste, and there are different considerations to take into account when working here.

Safety is an obvious thing to bear in mind. Even if the subject matter appeals, the necessity of hanging around in often insalubrious areas is not everyone's cup of tea. Access to industrial and derelict sites is also becoming more difficult and it's a constant frustration to see prime sketching material that one cannot get access to. Fortunately, there are more inviting options, such as mining museums and canals, which are safe and enjoyable places to sit and sketch.

The criteria for composing an interesting industrial scene are exactly the same as for a landscape or townscape in that we must use the rules of S.E.T. in the same way. I think what sets an industrial scene apart from other landscapes is that the shapes are more unusual. Our dominant horizontals will be unique and should say 'industry' as opposed to town or countryside (see page 26 for more on taking a line for a walk).

Our verticals will not be trees or churches, but cranes and lighting towers. There may be atmosphere suggested by smoke or steam and colours can be interesting too. Simplification comes into its own in the industrial landscape as well: structural steelwork and general industrial clutter will overwhelm the artist who is unable to fuse and omit.

Old coke car studies, Grange Coke Ovens

I was 'lucky' enough to work in a steelworks, and there was sketching everywhere. I would often take my lunch out on site, and sketches such as this are the result. To record these stark, bold forms, I have tried not to outline, but instead record the mid- and dark tones. Lines, where they exist, are broken or lost-and-found to retain a sense of life and dynamism.

Collow Pill, River Severn

Not a typical subject, but a cracker nonetheless. To get the sketch, I first had to take a zoomed-in photograph on my tablet from the opposite bank. I then retreated to the camper van for a cup of tea and did the sketch from the photograph.

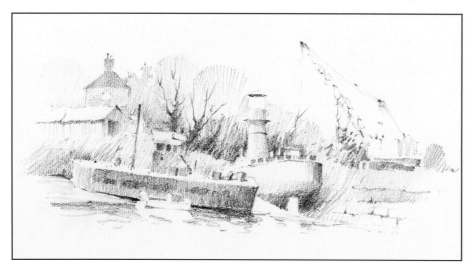

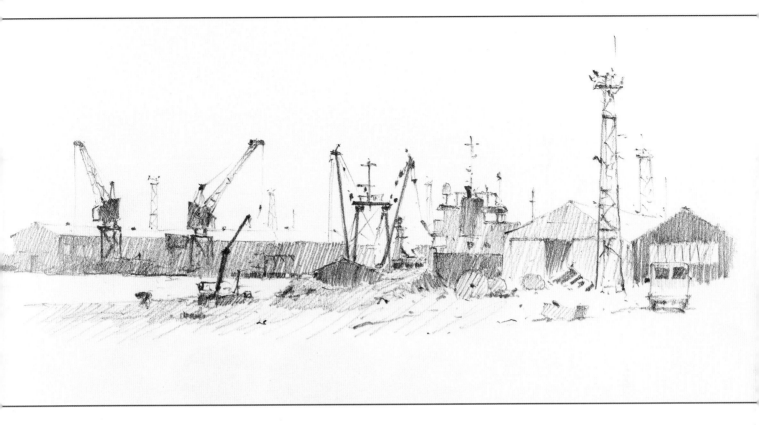

Swansea docks

I do not think that I would have sketched this if the boats and cranes were not present, but they break up the straight lines of the buildings and stand out against the light sky while their lower sections almost fuse with the buildings.

I started by running a light line between sky and land, ignoring the cranes and boats at this stage and enjoying the repetition of the three triangles contained within the gable ends of the buildings. I then indicated the wedge of water between the foreground and distant building, after which I ran a light hatch across the picture. At this stage the large empty foreground was cropped – that is, cut away – in order to make a better composition.

I left the roofs as white paper and indicated their presence by placing the roof vents and a light 'lost and found' line.

The next step was to hatch some deeper tone into the buildings keeping it fairly soft and fused, leaving room for the good, strong, staccato darks of the boats and cranes. I tried to vary the weight on the pencil as I drew these to allow for strong, dark little accents where I wished to pull the eye. Finally I added extra lighting towers and bric-a-brac to the foreground.

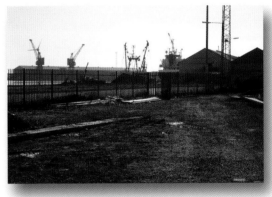

Source photograph

Boat Sheds

This final project combines the techniques and information on S.E.T. explained through the book. By the time you finish it, you'll be all set to sketch absolutely anything you like.

You will need:

Paper: sketchbook or a piece of cartridge paper

Pencils: 3B graphite pencil

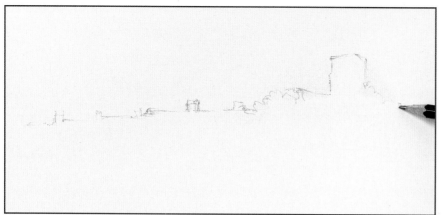

1 Use the 3B pencil to establish the skyline with a dominant horizontal.

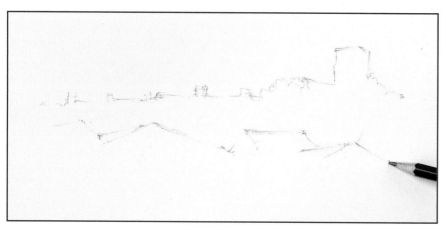

2 Add the next dominant horizontal loosely and lightly, using the previous horizontal to help with placement.

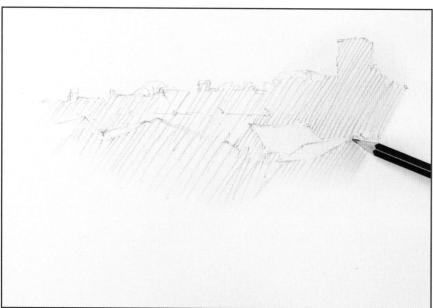

3 Add a few additional marks in the background, then add an overall hatch. Work away from areas that you want to keep light: isolating the whites so that the boat sheds of the title come into focus.

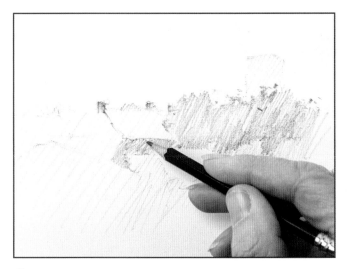

4 Strengthen the backdrop with more hatching. Leave certain portions as the original hatch – the intention is to suggest the difference in tone. As you work through the sketch, feel free to pick out shapes and details, but do concentrate on getting the big shapes to read out.

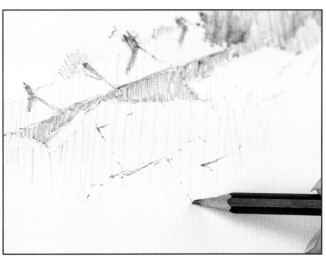

5 Lightly indicate some foreground shapes, such as windows in the main buildings, to retain as light areas later.

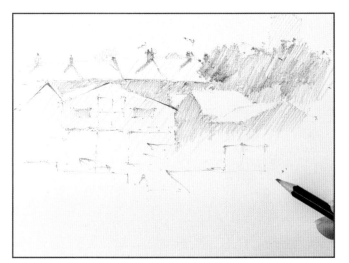

6 Add another dominant horizontal along the harbour wall, incorporating all the shapes that cross it, including the boats, figures and so forth.

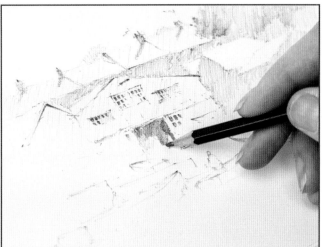

7 Add a final dominant horiontal along the waterline itself. Flesh out the shapes here, too. With these lines in place, you can now begin to refine and add detail to the midground, building up the repetition and variation with the shapes and tones of the windows.

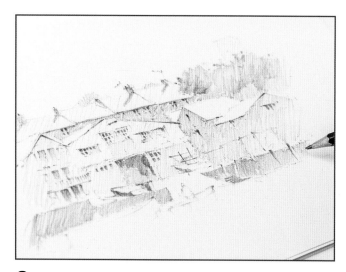

8 Work into the foreground, building up the harbour wall. Note that I've made the tone quite strong and dark here, to contrast with the water we'll develop in the next steps.

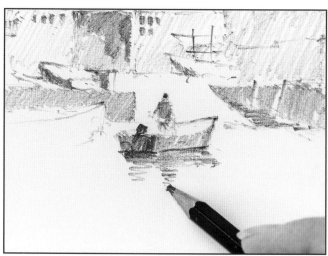

9 When adding the boats, add the reflection at the same time with horizontal, wiggling marks. All reflections merge and flatten tones, so the varied tones of the boats can be largely merged into one in the reflections.

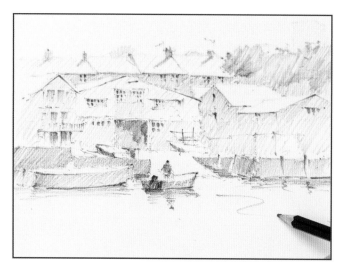

10 Continue to develop the foreground, building up details across the sketch. Keep marks in the water itself light and loose.

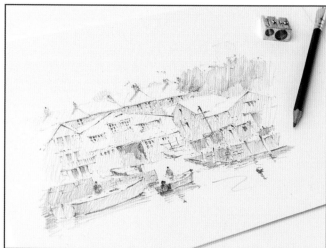

11 With the background, midground and foreground all in place, have a look at the overall picture. Feel free to add bric-a-brac and details here and there. Make sure that such additions are not just for the sake of it, but to help reinforce the story – in this case, to draw the eye to the boat sheds of the title.

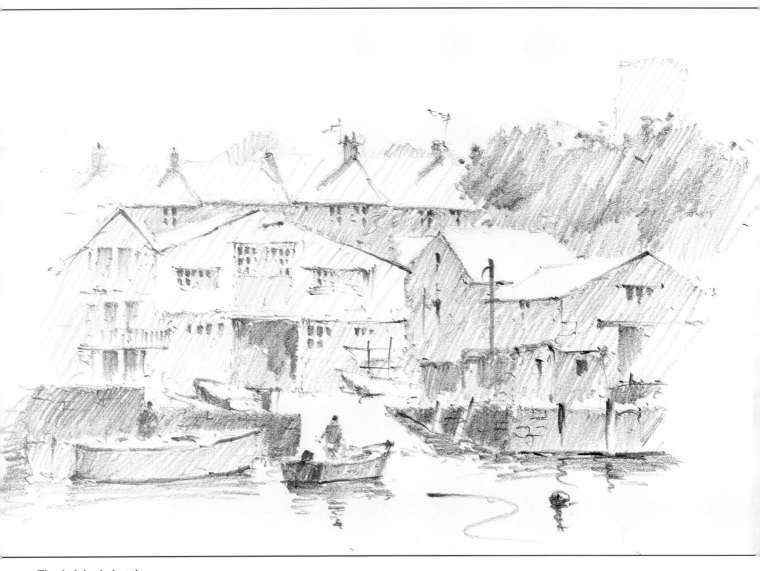

The finished sketch

Afterword

If you have studied, absorbed and practised the methods outlined and explained in the earlier chapters of this book, then the final sections should have slotted nicely into place. You will have put lots of graphite onto lots of paper, experienced bitter frustration and failure, yes, but also that slowly maturing feeling that comes from all hard effort: understanding.

You should now be starting to look at the world rather differently, and hopefully all that we have so far discussed has equipped you with a 'method' to identify and translate what you see and, just as importantly, feel.

So thank you for coming 'out and about' with me, to meet some of my favourite subjects, in some of my favourite places, to discuss and demonstrate what using the hand, head and heart, means to me.

The Sketchbook

So come with me to empty spaces, busy towns and lost byways.
Come with me, pack a sandwich, a sketchbook and a pencil.
Come with me to look at the world anew,
and place some marks – your marks – on a simple sheet of paper.
The world is a richer place when we use a sketchbook.
It reveals itself, unfurling, beneath our hand; and we are left with a book of rich memories:
Our memories.
And they rest in isolation from the bustle and troubles.
Thoughts that never seem to intrude onto the page.
And I smile when my sketchbook is in my hand...
I always smile.

Peter Cronin

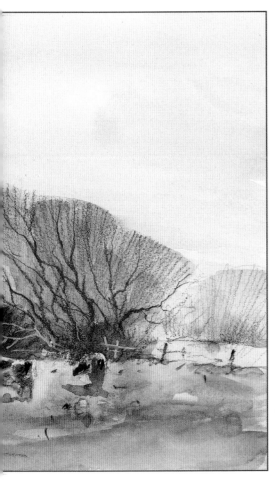

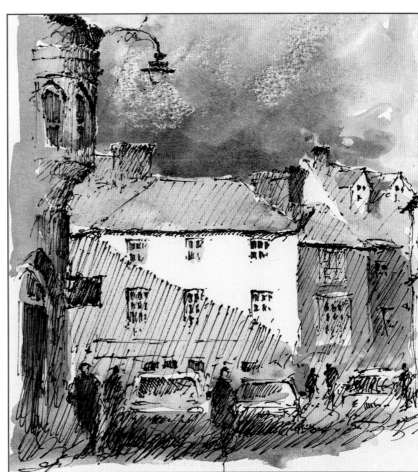

Clockwise from above:

Cows and Barn

A very rapid pencil and wash – necessarily so, as I was standing on a precariously slippery bank at the time.

Brecon Rain

I stood huddled by the church railings and managed to capture a pen and wash of this between deluges of rain.

Winter Copse

A sepia pen was used here. A mass of rooks were slowly making their way across the ploughed field, ignoring me stood alone like a winter scarecrow.

Blast Furnace

A sketch from my previous life over twenty years ago. I am so glad that I 'took a pencil for a walk'. Every day, I relish both the joy that the humble pencil has brought to me; and the journey on which it has taken me over the years that I have kept its company.

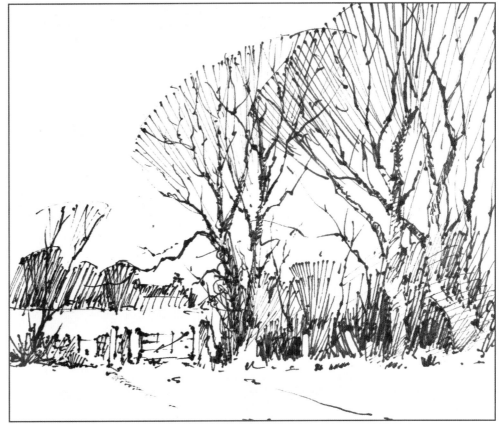

Index